D0117743

WONDER WOMEN

WONDER WOMEN

FEMINISMS
AND SUPERHEROES

LILLIAN S. ROBINSON

ROUTLEDGE
NEW YORK & LONDON

Published in 2004 by
Routledge
29 West 35th Street
New York, NY 10001
www.routledge-ny.com

Published in Great Britain by
Routledge
11 New Fetter Lane
London EC4P 4EE
www.routledge.co.uk

Printed in the United States of America on acid-free paper.

10 9 8 7 6 5 4 3 2

Library of Congress Cataloging-in-Publication Data

Robinson, Lillian S.
 Wonder women : feminisms and superheroes / Lillian S. Robinson.
 p. cm.
Includes bibliographical references and index.
 ISBN 0-415-96631-0 (alk. paper) — ISBN 0-415-96632-9 (pbk. : alk.
paper)
 1. Comic books, strips, etc.—United States—History and criticism.
2. Women heroes in literature. I. Title.
 PN6725.R64 2004
 741.5'973—dc22

 2003022831

In loving memory of
Wanda Edwards
artist, black feminist superhero,
charter member of the *real* Justice League of America

Contents

Preface

SOME TIME BACK, the *Broom Hilda* strip featured a conversation in which the title character announces, "My boyfriend calls me 'Wonder Woman.'" Her interlocutor asks if she owes this appellation to some special powers. Well, no, it's because "he wonders if I'm a woman."

The actual Wonder Woman, the superhero, arouses awe because she is powerful in ways that women are not traditionally supposed to be. Broom Hilda possesses extraordinary powers, too, but no one would call her a superhero, much less perceive any incongruity between her female identity and those powers. There is, in fact, no such incongruity. She is a witch, after all, so her feats never evoke wonder (in the sense of awe). Rather, her unattractiveness and her sexual aggressivity combine to provoke wonder (in the sense of doubt) as to her gender. Broom Hilda may be able to do some things that an ordinary woman cannot, but she's a patent failure at the one feat that many women who possess no special powers can manage: she can't get a man.

With its comparatively mild but persistent misogyny, *Broom Hilda* is as incongruous in the world of post-1970 daily comics as the original feminist Wonder Woman was in the male-dominated world of 1940s and 1950s comic books. But Wonder Woman, now more than sixty years old, has not only survived—or, more accurately, been repeatedly reborn and reinvented—but has been joined by other female superheroes, from Mary Marvel and Supergirl in the '40s and '50s to Invisible Girl in the '60s (growing up, of course, into Invisible Woman, in the '70s and beyond) to She-Hulk in the '80s and to

Elektra and Xena, Warrior Princess, in the '90s and into the new millennium.

The rebirth of feminism has obviously had something to do with the proliferation and redefinition of wonder women, but the connections cannot be encompassed by a simple formula about how images of female power are more acceptable—even desirable—nowadays, than they were in the past. The incongruity between gender conventions and warrior women persists, but is challenged by alternative models of gender and a social context in which the lesbian connotations of "Amazon" no longer have to be buried in a hyperhetero narrative closet. Even if they're "unfeminine" in their heroism, hypermuscular in their construction, or lesbian-identified in their sexual relations, nobody wonders whether they're women.

Meanwhile, the comic book genre itself has been far from static. The evolution of the two mainstream superhero clusters, DC and Marvel Comics, from "primitive" into "postmodern" stages, entailing mutual influence of the two strains, as well as the impact of underground "comix" on both, has transformed what we mean by "comic books" and, reciprocally, what "comic books" mean. Multiple approaches to heroic narrative are also at issue, and the social and cultural phenomenon called "postfeminism" may also be exerting its influence. It is in this constellation of contexts that the changing representation of the (super-) empowered female body has to be understood.

All of which—the body, the myths, the evolution of the comics genre, and the politics—is what this book is about. My own identity as an early reader and an aging commentator on the female superhero is also abundantly present in the text. Although that presence as reader and critic is probably as close as I'll ever get to a memoir, it was only as I neared completion that my body also entered the story. I was in the women's room at the McGill University Faculty Club when I went flying—not as Mary Marvel or Supergirl flies, but as someone does who, elated after a successful guest lecture, forgets that

the toilet stall she's leaving is situated one steep marble step up from the rest of the washroom!

I ascertained that nothing was broken, and noticed the pain in my right knee only an hour or so later, when I rose to take leave of my hostess and make my way slowly down the elegant central staircase. Nonetheless, I proceeded to a rehearsal of Eve Ensler's *The Vagina Monologues*. (My monologue was "The Flood," the one that begins with the striking words, "Down there? I haven't been down there since 1953.") It was more than five hours after the fall (catch the subtle reference to Eve, who comes up, naturally, at the end of my chapter called "The Book of Lilith," as well as in the "Genesis" chapter, which follows it) that I returned home and climbed into a hot bath. I knew a cold compress was the standard therapy, but holistic practitioners always tell us, "Listen to your body," and in Montreal in the last days of January, anyone's body cries out for *warmth*! I soaked, I luxuriated, I added more hot water as the bath cooled, I read a chapter or two of a murder mystery, and, when it was time to get out, I found I simply couldn't!

For ten or fifteen minutes, I struggled with gravity as the buoyancy afforded by a full tub proved insufficient to counteract the agony in my knee. Even the catastrophes I imagined—being stuck all night in the bath, prey to a quick death by drowning as I drifted off to sleep or a slow one from pneumonia after prolonged exposure and ignominious removal by a derrick—failed, literally, to move me. All my efforts served only to exacerbate the pain and splash water on the bathroom floor.

Finally, I asked myself, "What would Wonder Woman do?" And then, lacking her superpowers or her Amazonian armory, I evoked the hero herself. "Wonder Woman, help me!" I cried, and, with a gasp and one last effort, I swung myself triumphantly up and over the rim of the tub, dried off, and limped into the bedroom. I realized that never before, in childhood or since, had I used Wonder Woman as an almost literal crutch. Even in 1945, I didn't stoop that far down

there! In 1953, the year my *Vagina Monologues* character had her apocalyptic sexual initiation, the psychoanalyst Frederic Wertham highlighted the suspect "mutual rescuing" indulged in by Wonder Woman and her band of "gay girls." More about *him* later. Meanwhile, here I was engaged in the same mutual activity: Wonder Woman rescued me from my absurd predicament in the bath, while I, in return, am trying to rescue her from an ultimately hollow status as an unexamined pop icon! And, in the mutuality, my aging, overweight, injured body played a role right up there with her constantly redefined and reworked physical perfection.

As I complete this project, I owe thanks to many people who gave me different kinds of help along the way. In the 1940s, my brother, Professor Edward J. Robinson, of the NYU Physics Department (I mean now, not then), shared with me both his comic books and his enthusiasm for the genre. Indirectly, he also contributed to my interest in the comics as a subject for critical inquiry. I was raised on the family story of how, caught unprepared by the first manifestation of the motion sickness that was to plague my childhood, my mother snatched the comic book out of my brother's hands to wipe up the mess I'd made vomiting on the subway. I was a year and a half old, I'm informed, so Ed was six, engrossed in a recap of Superman's origins story, until that day's reading was brought to an abrupt and revolting end.

Nearly a quarter of a century later, when Jules Feiffer's *The Great Comic Book Heroes* (1965) was published at what then seemed like an exorbitant price for a paperback—it cost all of $10, I think—I bought it for my brother as payback with interest for his lost ten-cent comic. He was already an assistant professor and I was a PhD candidate, so it seemed pretty funny, a gesture steeped in irony, to be evoking our long-ago days of comic book reading. But Feiffer's was the first attempt to analyze adventure comics and their appeal, and the purchase introduced me, early in my career as a critic, to the notion that it was possible to do so.

Perhaps most important, from our childhood on, my brother has offered me the support I need to learn to fly on my own imagined wings. If I fall down in one bathroom and get stuck in another, both with maximum absence of heroism, I nonetheless learned to pull myself up again and, far from incidentally, to negotiate the worlds of the intellect and the imagination from Ed's example and encouragement.

His younger son, my nephew Professor Greg Robinson of the Department of History at the Université du Québec à Montréal, has been of great help in the choice and acquisition of comic books, in print and on microfilm, and in helping me to place my reading in historical context. In the final hours of typing the manuscript, he also helped with that far less creative task. Greg's partner, Heng Wee Tan, by passing on to me his copy of *The Amazing Adventures of Kavalier & Clay* by Michael Chabon (2000), enabled me, at a crucial moment in my work, to see the comics as providing both a worldview and a context for American life. Professor Don Palumbo of East Carolina University lent me his entire run of *She-Hulk* for a two-year period, as well as sharing his insights into that green goddess.

As for the book itself, my thanks to Susan Fernandez, who had enough confidence in me to place it under contract with a publisher both of us have now left, and to Bill Germano at Routledge, whose faith in this work enabled me to make that move and whose encouragement (not to say constant nagging) has enabled me to complete it. I am grateful, as well, to Robyn Diner, my research assistant at Concordia University, whose grasp of feminist popular culture criticism has been invaluable. Generous material support came from the research start-up funds and the General Research Fund of Concordia's Faculty of Arts and Science. Special thanks go to Dean Martin Singer.

For both intellectual and personal support, my loving thanks to Jane and Michael Marcus, Rick Berg, and the late Toni Robinson. Toni was my sister (-in-law, if that technicality matters) for nearly forty-three years. She was also my attorney, my self-appointed literary manager, and my friend. Both her life and her death—one of four

that took place in my immediate family during the final months of this book's composition—showed me a courage that surpasses any superhero's.

Wanda Edwards, to whom this book is dedicated, was my student at SUNY/Buffalo in the 1970s and my friend until her untimely death some twenty years later. A stalwart black feminist, Wanda was an artist, an advocate for prisoners' rights, and an ardent fan of women's comic art. She was also one of the funniest people I've ever known. The last time I saw her, she drove me to the Buffalo airport after a guest lecture and gave me a little package. When I opened it, I found it was one of Lynda Barry's wonderful books, subsisting on that unguarded frontier between the comics and the graphic novel, about working-class adolescent life. So my last words to Wanda that day were, "Hey, do you know I once published an article on Wonder Woman?" Aside from "thank you" and "goodbye," these also happened to be the last words I ever said to her. It turned out that they looked forward, as well as back, which is the right thing to do when remembering Wanda.

One

Flight Plan

JAZZ. THE MOVIES. THE COMICS. These three art forms are the quintessence of American popular culture in the twentieth century and beyond. Some might go further and maintain that they encapsulate American culture as a whole. What is certain is that they embody key themes in U.S. society and reflect them back in ways that have helped shape that society. They have also refracted, influencing music, cinema, and visual art around the world, while providing the context and subject for "high" art in their own country.

Thus, for example, to many readers, *The Great Gatsby* and its eponymous protagonist represent "The Jazz Age" in the history of white American culture; the first major talking film, Al Jolson's *The Jazz Singer*, makes use of the musical style to situate its story about conflict and accommodation of minority and mainstream cultures; and Toni Morrison's novel *Jazz* restores the music to its black history in the same period. Similarly, although world cinema may have grown away from its American roots in many directions, the French "new wave" can be said to start with Belmondo's small-time thug in *Breathless* straightening up in homage before a poster of Bogart, while Hollywood itself remains an iconic setting for major American literature from Fitzgerald and Nathanael West forward.

Jazz. The movies. The comics. And the least of these is the comics. Not in terms of their influence, where Mickey Mouse may

still be the best known "star" of American film, where "graphic novels" on themes as grave as the Holocaust invade regular bookstores, and where the Pop Art movement made its statements about America by simultaneously appropriating and satirizing the traditional styles of "romance" and "adventure" comics. Still, it was not until the turn of the millennium, with *The Amazing Adventures of Kavalier & Clay,* that a single major work of American fiction utilized the world of the comic book—its production, its imagery and tropes, its mentality, and its pace—for a literary setting and subject. ("Major" is a controversial word, but, whatever Michael Chabon's place in canons yet to be codified, his novel did win the Pulitzer Prize for 2001.)

If the comics have come last and still ambiguously to recognition as cultural expression, they have been even slower to receive critical attention commensurate with their cultural significance. As the study of mass media and the more complex field known as cultural studies have developed, their practitioners have shown little interest in the comics, as compared with other popular culture forms. To take only one example, I am writing this on a campus that boasts a department of Cinema Studies, a performance-oriented major in Jazz Studies, and a specialty in animated filmmaking, but where there is no place for critical attention to the comics.[1]

With few exceptions, the books devoted to the comics are celebrations of the genre, more or less directly tied to the industry that brings us the comics themselves. This may happen because the stigma that is still attached to criticism of mass culture artifacts—a contempt carefully nurtured by the media themselves—is exacerbated, in the case of the comics, by the sin of looking critically and, even worse, looking ideologically, at material originally addressed to children. Although the stories the comics tell us constitute an American narrative that is well worth examining through some of the lenses developed for studying other cultural phenomena, "comic book studies" *must* look even sillier than the kind of cultural studies satirized in Don DeLillo's *White Noise,* where the hero is a professor of "Hitler Stud-

ies," and he and his male colleagues pass their lunch hours ardently competing to elaborate on what they were doing when they learned that James Dean was dead! (Some months after I wrote this sentence, I discovered that, in *How to Read Superhero Comics and Why* [2002], Geoff Klock anticipates precisely this dismissive comparison. In a note that is part defense and part defiance, he includes among the literary quotations that constitute his study's "Endpapers" one of DeLillo's most telling passages about "Hitler Studies.")

Elsewhere on the silliness index, the Italian newspaper *Paese Sera*, whose politics were close to the line of that country's Communist Party, evoked only derision in the early '60s, when it ran a heavy-handed analysis of *Peanuts*. This was an article in which the incorrigible Lucy van Pelt (she who annually whisks the football away from Charlie Brown at the last moment and languishes with unrequited passion for Schroeder, who cares for nothing but wresting Beethoven's chords out of a toy piano) was characterized as a fascist. The critique was crude, to be sure, but, once the American press learned about *Paese Sera*'s daring assault, its class analysis was rejected because it was a class analysis, not just because it was bad criticism.

By the time Armand Mattelart and Ariel Dorfman provided instructions on *How to Read Donald Duck* (1971), its more nuanced approach convinced those who were ready to hear it that popular culture could embody and promote a politics. And more Americans were open to that suggestion because the history of the intervening decade made it important to consider the role of the media in the formation of ideology. For that very reason, though, *How to Read Donald Duck* was influential chiefly among those for whom the '60s had entailed a positive struggle for peace and justice. The mainstream media, which managed, after all, to keep their cool in the face of the CIA-backed coup in Chile, where the book was first published, continued to dismiss its critique of Disney as an example of the doctrinaire excesses of socialism in the Allende years. Ducks hoarding great wealth, ducks forming themselves into generations of uncles and

nephews apparently without intervention of reproductive sex or personal tenderness—you'd simply have to be a humorless cultural commissar to think these images said anything about the greed and sterility of American capitalism! Wouldn't you?

Still, even before the dramatic shift that opened at least some American eyes to the value of looking critically at the comics, *Peanuts* had been situated in another critical grid that did *not* enrage the American public. *The Gospel According to Peanuts* (1965) drew nothing like the readership of the daily strip and its offshoots in book form, nor could it even rival the sales of stuffed Snoopys or Charlie Brown mugs and T-shirts. But, with cartoonist Charles Schulz's blessing, it was on sale all over the country, making its point that the *Peanuts* story could be read as a contribution to Christian exegesis. This worked better than the *Paese Sera* approach partly because it was presented in an appropriately playful spirit, partly because Americans are more comfortable with God-talk than with class-talk, and partly because it came closer to describing what *Peanuts* actually does.

Another factor, and the reason I dwell on an otherwise long-forgotten novelty volume, is that its reading of *Peanuts* resonates with the mythopoeic dimension of the comics in general and adventure comics in particular.[2] The Greco-Roman myths have always been decidedly to the fore in those comics, but the Norse and Arthurian legends and the Bible have also been fruitful sources of names, archetypes, and incidents. And the addition (not to mention the confusion) of magic and science, the intervention of extraterrestrial forces, and the creation of new and original pantheons underscore the mythmaking potential of the comic book form. The various and often conflated uses of mythology are not normally presented as alternative belief systems, but rather as sources of powerful and evocative imagery. By contrast, *Peanuts* was analyzed, at least in that one critical text, as a way of retelling the Christian narrative. The *Peanuts* story was identified as being *about* belief, and the less it looked like the New Testament, the more it could be understood as an allegory of the New Testament's essential narrative. In that sense, *The Gospel According*

4

to Peanuts was about a way of reading the Gospels, not a way of reading comic strips.

What adventure comics get from mythology is a ready-made pool from which to select stories about gods and heroes, who, like many epic heroes in the Western tradition, may be divinely empowered. It is the act of selection that is key, for, lacking the subtlety of most familiar mythologies, traditional comic narrative is based on the conflict between Good and Evil, both understood in absolute terms. The cause for which comic heroes are enlisted is, by generic definition, the good fight, whether the enemy is the national foe in hot or cold war or the antisocial agent whose crime disrupts the ordered life of a community. There are—at least in the primal DC version of things—no gray areas.

By contrast, in the Greek and Roman epics, the gods themselves—with their attendant foibles, their selfishness, nepotism, and partisanship—are enrolled on both sides of every battle. In the Old and New Testaments, not only are human beings presented as fallible members of human families at least as dysfunctional as the immortal ones on Olympus or Asgard, but divine justice itself is frequently represented as biased and irascible. Similar mythic struggles to bring order out of chaos and meaning out of devastation rarely come to the fore in the comics, where the moral definitions are fundamental and fixed categories.

But, however little of real depth or substance the comics borrowed from the treasure house of myth, that little was essential. It became all the more so from the 1960s forward, as Marvel Comics introduced irony and ambiguity into comic narrative. Marvel's heroes question and even seek to reject their special powers, while the powers themselves may often be represented as mutations or abnormalities, and traditional gender roles are open to interrogation and challenge. The ambiguity has its limits, though, within which the polarities of Good versus Evil—now sometimes called Life versus Death—are still operative, and even more mythologies are plumbed in Marvel's more elaborate narratives. Because of the characteristic Marvel

irony, the sense that these comics are taking even *themselves* with a grain of salt, the multiple layers of myth offer no more challenge than do the DC-style comics to the beliefs held by readers raised in mainstream American Christianity or Judaism, nor are they meant to offer a spiritual alternative to those raised outside of a religious tradition. Even when it is the Bible, rather than pagan myth that they refer to, the comics belong to a different level of story.

Maybe it's belaboring the obvious to say that reading the Gospels through *Peanuts* or reading a comic from a religious publishing house about, say, David and Goliath or Jesus's more spectacular miracles is different from reading adventure comics' versions of myth and epic. "Duh!" as my students remark when anyone, themselves included, makes such self-evident statements. I risk the "duh" response, however, because I plan to argue that stories of female superheroes make another, more transgressive use of mythological sources, borrowing from various traditions and creating new ones in order to tell different stories about gender, stories that come closer to the universe of belief than do masculine (and masculinist) adventure comics.

The immanence of an alternative and implicitly feminist mythology in the stories of female superheroes is one of the unexplored aspects of these comics, for the general critical silence around the comics is only deepened when it comes to feminist criticism, which has produced even less study of the form than the pop-culture mainstream. Indeed, the overwhelming majority of books devoted to the female superhero—for example, Trina Robbins's *The Great Women Super Heroes* (1996) and Les Daniels's *Wonder Woman: The Complete History* (2000)—can most charitably be characterized as "*uncritical*," describing, detailing, and cherishing their subject, rather than analyzing it. I think this uniquely uncritical approach—uniquely uncritical, that is, for feminism, which has rarely hesitated to question most other established institutions and verities—is due to the preference for a heroic icon over an understanding of how the representation of such an icon derives from and serves—as well as challenges—the dominant social forces. Perhaps it is fair to say that, in

this case, at least, feminists behave as if they are unconvinced that cultural studies is a useful political weapon, whereas the value of the icon goes unquestioned.

Critical analysis of an icon can enhance its power, as well as challenge it. Some of this effect occurs through the use to which the adventures of female superheroes put the mythological tradition. Whereas male adventure comics borrow chiefly the names and salient attributes of mythological figures, thus appropriating the status of authentic epic for what are ultimately rather superficial versions of myth, the tales of female superheroes embellish and extend the myths or turn them inside out. In the process of saying something new about gender relations, they call upon several traditions of mythology, but they also show the courage and creativity to adapt and even correct these stories. Nonetheless, if they are not constrained by long-standing narrative tradition, they face other failures of the political imagination.

In this book, I want to begin the work of examining the comics from a feminist perspective, taking them seriously without exaggerating their importance in either reflecting or shaping our culture, and enjoying what they have to offer without becoming the mouthpiece of the mass culture industry. Because the female superhero originates in an act of criticism—a challenge to the masculinist world of superhero adventures—Wonder Woman, her epigones, and her descendants are my point of departure. Because the narrative of Wonder Woman begins with the agon between Mars and Aphrodite, war and love, I pay attention to the myths to which the comics make reference and the new ones they create. And because feminism is not exclusively—not even primarily—a matter of role models and symbolic butt-kicking, but is rather a worldview directed at understanding and remaking society, I make further demands on the stories the comics tell us about female superheroes.

The body of the book is divided into three chapters, "Genesis," "Chronicles," and "Revelation." It seems to me that this audacious appropriation is no more blasphemous than Captain Marvel's magical

invocation of Solomon for wisdom, the *S* of Shazam juxtaposed with the *H* of Hercules for strength. My intention is to recall, even in the structure of my own critical work, the deep narrative traditions from which this lightest genre of storytelling springs (or leaps or flies). I have filled out the structure constituted by these three major sections by beginning my critical effort with what movie marketing has taught us to call a "prequel," "The Book of Lilith," and ending with a vision of the cultural work that lies ahead of the female superhero.

In the book's central section, "Genesis" is obviously devoted to the origin of the female superhero in the person of Wonder Woman. "Chronicles" explores the superhero icon from the 1950s to the 1970s, longitudinally through the evolution (or devolution) of Wonder Woman herself, latitudinally through the ramifications of other such figures. "Revelation" considers the modern and postmodern variations on the superhero theme, in the latest versions of *Wonder Woman* as well as in a new generation, a third wave, of feminism.

Despite the siren song of underground comix, especially feminist ones, Japanese *manga* and anime, the televised *Xena,* graphic novels, and other avatars of the icon, I confine myself, throughout, to mainstream American mass-circulation adventure comics. Only when I suspect that the alternative forms influenced the original genre—much as I am convinced that pop art's use of comic book imagery had an impact on the actual comics—do these alternative forms enter my discussion.

Another caution may be in order: analyzing comic books is not meant to take the joy out of them any more than any other form of criticism is meant to deprive the reader of pleasure in its object. Mass media, which have their own reasons for deriding any attempt to invest them with social significance, tend to portray the critic as a professional faultfinder. By contrast, it is because I love the comics that I want to share what I think about them with others interested in American culture, casting an analytic eye on the stories they have told us so far and wondering aloud what further stories they have yet to tell.

Notes

1. Concordia's innovative department of Communication Studies does have a couple of MA students, at the moment, working on comic books, but no faculty who specialize in this area. The department also teaches *How to Read Donald Duck* as a classic of the field.
2. Whoops! Far from being a long-forgotten novelty item, *The Gospel According to Peanuts* was reissued in 2000 and is currently selling much better on Amazon (not Wonder Woman the Amazon, but the electronic book dealer of that name) than any book of mine!

Two

The Book of Lilith

The story of Lilith, Adam's first wife, notably absent from the Bible in its canonical form, is an alternative story of humanity's origins—another, purportedly earlier, version of the creation. My Lilith is not about the genesis of the female superhero, but rather about my own history as her commentator. It begins with my first attempt at comic book criticism, a short piece called "Looking for Wonder Woman," solicited by and published in Artforum *in 1989, and continues through my reflections on the article. The piece draws on my own experience as a reader, reaching as far back as the last weeks of World War II, and narrating the history of this particular reader as a way into the history of what she was reading. I accepted the* Artforum *commission because I thought it would be fun. It was, and the origins of the present project lie as much in that pleasure as in my growing sense of the topic's importance to cultural studies.*

Looking for Wonder Woman

I always skipped the secret-identity parts of *Wonder Woman* comics, those segments in which she wore a blue military uniform and rimless spectacles instead of the star-spangled costume designed by the Amazon Queen, her mother. Although Wonder Woman's boyfriend, a blond army intelligence pilot, also appeared in the action segments,

to my mind he represented a real menace in the scenes in which retiring "Diana Prince" was merely a WAC clerk with a terrible crush on him. With good reason, moreover, since he was responsible for Wonder Woman's double identity in the first place. For after Steve Trevor crash-landed, a sort of preppy *ex machina*, on Paradise Island, he was nursed by the Amazon princess, who fell in love with him and insisted on following him back to the United States. Wonder Woman's embrace of Steve Trevor also meant an embrace of his cause and his country, so in both Amazon and WAC avatars, she enlisted on the Allied side in World War II. The goddesses Aphrodite and Athena endorsed this decision of the heart in an appearance before Wonder Woman's mother, Hippolyte, the Queen of the Amazons, calling America "the last citadel of democracy and of equal rights for women" (*Wonder Woman* 1, no. 1, 1942). But Wonder Woman's WAC persona made me uneasy nonetheless, and, at whatever sacrifice of narrative coherence, I tended to ignore the frames that featured it.

Male comic book heroes were a different story. I *relished* the dramatic irony of nerdy Clark Kent's interactions with people who were unaware that they were really dealing with Superman. Likewise, copyboy Billy Batson, whom I—but not his own coworkers—knew was really Captain Marvel. As for Freddie Freeman, the crippled newsboy who had only to recite a ritual formula to turn into Captain Marvel Junior, his superhero status was only enhanced by his apparent disability. It was just Wonder Woman whose secret identity threatened to overwhelm and swallow up the heroic reality. I think I was afraid that one day I'd innocently open that month's comic and find Diana Prince waking up to announce that Wonder Woman was only a dream after all. (Sure, that would have been a trite and derivative device, but hell, this is a genre that mixes convention and innovation in daring ways. Who's to *guarantee* that they'd stop short of the "and-then-I-woke-up" device?)

I don't think this was merely paranoia. The dominant cultural message of my growing-up years was precisely that awakening to

womanhood meant abandoning the heroic identity of the war years for domesticity, motherhood, and consumerism. Indeed, World War II, Wonder Woman's war, was well over by the time I could read comics, with the wicked enemy no longer the identifiable Axis but a vague international conspiracy, and the place for women in this new, this chillier war was firmly on the home front.

Actually, I did learn to read in the last months of the war, if hardly at superhero level. One day, I sounded out the words BUY WAR BONDS as a skywriting plane—Steve Trevor at the controls?—formed the letters. "After the war," a neighbor child informed me confidently, "they'll write DRINK PEPSI COLA up there." I was positive such desecration would never come to pass. But by the time I was devouring monthly installments of *Wonder Woman,* substances far worse than Pepsi had been splashed across the firmament. If the '50s could make heaven itself into a billboard, Wonder Woman might well be the next icon to go.[1]

I didn't know she was an icon, of course. But she was certainly the apotheosis of the female hero I also sought in fiction closer to home. It was what drew me, bookish and klutzy as I was, to identify with all the tomboy characters in children's literature—because they were the only ones who openly challenged the traditional female role. What enchanted me about Wonder Woman was her physical power. That it was enrolled in the good fight was taken sufficiently for granted that I could concentrate on the power itself. Part of the charm was that, unlike Superman (who, if you come to think of it, was an alien from another planet and whose strength was thus measured on a different index), the wonder of Wonder Woman merged the natural and the supernatural, without reference to the extraterrestrial. She wasn't strong the way someone from Krypton would be (well *wouldn't* they?), but she was *skilled.* She had developed her abilities to a fine, a martial art. And if those abilities were still inadequate to the challenge, there were always her magic bracelets, and also her wondrous invisible airplane, and her headband radiotelepathy. Nor were these instruments a passive if divine gift: Wonder

Woman's skills included all the wonderful things she'd learned to do with them.

I had no idea that there were other stories about Amazons, enough to constitute a complex and varied myth. Rather, I learned the word *Amazon* from my comic books. For all I knew, it was Wonder Woman who was the prototype, the only Amazon, not a camped-up descendant of a classical figure. The prowess, the sheer physicality, of the true Amazon is acquired, legend tells us, at the expense of her female nature. The very name *Amazon* derives from the Greek words meaning "without a breast," for removing the right one solved the problem of how a normally constructed woman could operate the heavy bow used in ancient warfare. But voluntary sacrifice of a breast to military exigency clearly meant sacrificing one of the keys to women's physical distinctiveness, as well as the literally maternal and nurturing role it entailed. Amazons were also commonly supposed to be man-haters, rejecting what the myths uncritically presented as the paired experiences of heterosexuality and subordination. But in theory, at least, there could be warrior women with fully active heterosexual lives, and thus bearing and nurturing children as well. Submission, however, once they were armed, was another matter, which is presumably why Frederic Wertham, the Freudian critic of the comic genre, called Wonder Woman a lesbian and hence a "frightening image" for boys, a "morbid ideal" for girls (Wertham 1953, 193).

So that's one kind of wonder, military power expressed through a woman's body, once that body relinquishes conventional expectation. Even though Amazons were not presented as absolutely invincible—indeed, some of the myths involve their conquest by the forces of patriarchal civilization—still, the wonder of their skill increased exponentially with their numbers. (For Amazons are normally represented as acting in community, tribally. Even in America, Wonder Woman has a band of "the girls" to assist her valorous endeavors.) Thus the wonder is not omnipotence, but exceptional power *for a woman.*

Yet at the other extreme of the spectrum of female wonder (which I take to mean the ability to do something truly amazing) is the awe-inspiring capacity to bear and nurse children, precisely those capacities that Amazons were presumed to deny. Worship of nature's power to generate and sustain life, and identification of this creativity with the female principle, has been the hallmark of many cultures, both prehistoric and historic. Although this spiritual awe says nothing about the status of actual women in civilizations or periods when the Great Mother prevailed, it is nonetheless instructive to consider what the past two millennia in *our* culture have made of the image of the mother goddess.[2]

The proverbial naïf from another planet (Krypton, say?) touring the museums and cathedrals of Europe might well conclude that Western civilization centered on a high regard for maternity. Mother and baby (the same ones, but how's a poor alien to know?) are represented everywhere, occasionally in an image of triumphant pregnancy or serene nursing, sometimes in wonderstruck worship just after birth, most often simply posed together in such a way that the fact of their being is a statement in itself. If the space tourist had a good enough guidebook, all the Annunciations, Pietàs, Ascensions, and Assumptions would also take their place in the history of this particular wonder mother.

But the wonder of the Virgin Mary, as *her* name indicates, differs from that of the usual mother goddess in one crucial respect. Far from celebrating the wonder of the most fundamental creation all other kinds follow and emulate, the motherhood of Mary is the most special of special cases. She is the impossible union of the virgin and the mother. Honored above all womankind and cited as the exemplar of woman*hood*, she can be emulated in part by all women but in toto by none. The wonder of the Great Mother is connected to nature through sexuality—which is the medium of maternity—and to fertility, which it simultaneously symbolizes and assures. The wonder of the Great Mother of *Christian* worship and iconography, however, is her categorical distance from the realm of nature in general, and sex in particular.

For Catholics, Mary is also set apart from the rest of humanity by her removal from the stain of sin. Because of her sacred mission as virgin mother, she was the sole member of our species created, from conception, free of original sin. (The same sin that we daughters of Eve are condemned to expiate through the pain suffered in childbirth.) If you believe in original sin and also believe it to be the universal human condition, then Mary's immaculate state is as wondrous as her perpetual virginity. No wonder the nontheologically minded get the Virgin Birth and the Immaculate Conception mixed up!

So there is the Amazon version of female wonder, inspiring a sense of boundaries crossed or extended through military feats, offensive or defensive. And there is the maternal version, inspiring wonder at the capacity to bring forth new life. And, for our culture, the icon of the Amazon is Wonder Woman, with the awe built right into her nom de guerre. But she's the archetype with a difference, since she's fallen for a mortal male and the Amazon may at any moment be eclipsed into the conventional wife and eventual mommy. Meanwhile, the icon of maternal wonder in Western civilization remains Mary, but once again, with a difference. She is the mother who has not engaged in sex.

Is it ever possible, in the world of wonder, to put the pieces together, to have the experience and evoke the awe that is owing to both martial/political and reproductive accomplishment? Cultural history provides us with only a few clues. The women warriors of Renaissance epic poetry—Bradamante in Ariosto's *Orlando Furioso,* Clorinda in Tasso's *Jerusalem Delivered*, and Britomart in Spenser's *Faerie Queene*—are like Amazons to the extent that they are warrior women, indeed, knights errant fighting for a cause to which they are committed, and clearly relishing the casual fights as they arise. In the epics themselves, they are warrior *maidens,* but none of them shares with the archetype a removal from the world of men and heterosexual love. In the course of the narratives, each of them is involved in a love story. Each of them, in her capacity as a fighter, also engages in a duel with the man who loves her. If they joust twice, as is the most

usual pattern, the woman and the man each win one round. Where the story makes that possible, each couple marries in the end. They marry for love (rare at the time) on the basis (rarer still) of equality, and an equality (rarest of all) demonstrated in military combat.

The dynasty each pair of lovers establishes is the ruling-class family from which the poet's patrons claim descent. So it was an assertion of imperial legitimacy as well as a courtly compliment for these poets to be saying to the princes who employed them, "Your (many times) great-grandma wore combat boots."[3] The lady knights are wondrous, then, as both warriors and mothers (in fact they are that special kind of supermothers known as ancestresses). Their military and their maternal experiences are both related and predestined. But there is a developmental trajectory inscribed even in their destiny. They cease being warriors when they fulfill the prophecy leading to their role as founders of a ruling dynasty. They are warriors, and *then* they are mothers.

In their different ways, the Amazon, the Great Mother, and the Blessed Virgin exert a powerful hold on the Western imagination, whereas the lady knights never achieved the status of myth. Italian painters and composers ransacked the widely read epics of Ariosto and Tasso in search of material to translate into their own media. The result is that there are many visual representations of scenes from the two poems as well as quite a few operas and other musical renditions. But these almost invariably focus on other parts of the narratives, stories in which the female figures are victims to be rescued, enchantresses to be overcome, or simply out of the picture altogether.

The final duel between Tancredi and Clorinda is the sole exception, and that is the one case where the lady knight gets killed instead of married. Its best-known musical setting, Monteverdi's dramatic sequence of madrigals, concentrates on defeat and lamentation. But we are already in pretty arcane cultural territory here (compared, at least, with comic books), and music lovers unfamiliar with the literary source never meet Clorinda as the beautiful and triumphant Saracen warrior, nor do they get an inkling of the heroic exploits and dynastic contributions of her sister knights.

So it's back to the Wonder Woman story we go again to find the combination of Amazon and mother. For, before the time when we come to know her as either Wonder Woman or Diana Prince, Princess Diana is the daughter of Queen Hippolyte, wise and benevolent ruler of Paradise Island. Although all the Amazons of Paradise Island appear young and beautiful, there is a clear difference in generations between the queen, or the serious doctor who treats Steve Trevor, and the maidens who compete with the princess for the privilege of helping America win World War II. They are all immortal (the first episode tells us that Diana gives up both her heritage and, almost incidentally, eternal life to become Wonder Woman) and thus don't *need* reproduction and new generations to succeed them; but where did the two existing generations come from? How could Hippolyte ever have become a mother if the subsequent presence of merely one man on the island is so shocking and unsettling to her and to the other women? In my time as a reader, *Wonder Woman* never explained. It's the sort of thing we preadolescents were not supposed to be concerned with, and, indeed, I don't recall speculating on the whereabouts of the daddies who were so evidently absent from Paradise.

Yet an adult inventing however wondrous a narrative for other adults would have to think up an answer to questions about how a society without men arranged for reproductive continuity. In the children's version that *Wonder Woman* relates, there's only immortality (talk about women and wonder!) with a kind of pentimento trace, as in the case of the queen and her daughter, of familial bonds that suggest the intervention, at least at some point, of more familiar means of generation.

A man-free (occasionally a gender-free) society is often at the center of feminist utopian or fantasy fiction. Again, adult to adult, the matter of reproduction is explained: either there still are males, although patriarchy has been eliminated, or a new breed of beings "naturally" contains the reproductive apparatus of both sexes (or some other means of breeding); or the progress of science has made men irrelevant to reproductive technology. Each of these narrative solutions entails an element of the amazing, but none centers on a spe-

cifically female power to evoke wonder. By contrast, one of the earliest feminist utopias, Charlotte Perkins Gilman's *Herland* (1915), offers us an all-woman society that has continued for several centuries by the force of sheer female will. After the men in Herland's isolated mountain community were all killed in a savage war, the surviving women learned—slowly and through the force of concentrated maternal desire—to experience pregnancy and parturition independently. They have created a sane and serene community that has endured for generations. The reader may well wonder—in a sane and serene sort of way—at the superior organization Gilman attributes to a world without destructive passions. But the power of parthenogenesis through the creative passion, the passion for motherhood, is true, unadulterated wonder.

Are they still only occasional fantasies, then, these notions we cherish of the women who have this particular version of "it all"? Or is there another venue for Wonder Woman—perhaps in that daily life where, as a very young reader, I was so fearful of seeing her dwindle into a mere (and unwonderful) woman? And why, finally, am I looking for Wonder Woman? What do I—do we—need from that myth, even in its fragile comic book avatar? Well, the word *empowerment* trips rather too easily off the tongue these days, but it is an authentic need implicit in this particular discourse. The wonder of the woman warrior represents recognition of achievement at what is, in any event, exceptional for women. Arguably, women's historic subordination derives precisely from our incapacity for physical combat. But, outside the realm of myth, liberation does not mean a mere reversal of oppressor and oppressed, and female empowerment does not come out of the barrel of a gun. (Antonia Fraser's *The Warrior Queens* makes it abundantly clear that tyranny is no more acceptable when it wears a female face, or bloodshed no more noble when it is a woman who has ordered the slaughter.) Indeed, even my actionpacked *Wonder Woman* was intended by its creator as an alternative to gorier, male-oriented comics, as it tempered masculine violence with an "archetypal" feminine quality he called "love."

As for empowerment by mothering, one reason it's the conceptual opposite of Amazonism is that, rather than being exceptional for women, it is something only we can do. But in a society that does not honor children or childbearing, this wondrous capacity is far from empowering. As Flo Kennedy has bitterly quipped, "If men could get pregnant, abortion would be a sacrament." In that same unlikely eventuality, would pregnancy and maternity also be valued? And, in considering these possibilities, might it finally be understood that even though "only women can do it," it does not follow that this is woman's only valid creative act? For it has been fear of this latter assumption—an assumption that has deformed the lives of all women in our society, whether mothers or not—that makes us insist on relegating the mother goddess, like the Amazon, strictly to the universe of images. If the wonder evoked by the ability to be a mother is wonder, after all, at *difference,* that difference often threatens to obscure our common human possibilities—or rights.

In real life, nowadays, we're using another word from the comic book lexicon, *Superwoman,* to characterize someone who is a competent professional and also a competent homemaker and mother. But this Superwoman label bespeaks an underlying story about class as well as gender, because that heroic epithet is rarely applied to a woman raising a houseful of kids on her earnings as a waitress or a switchboard operator or a domestic servant. It is also a story about race, for, as Michele Wallace points out, the black woman is stereotyped as simultaneously "less of a woman in that she is less 'femininely' helpless . . . [but also] really *more* of a woman in that she is the embodiment of Mother Earth. . . . In other words she is a superwoman" (Wallace 1979, 107). Nevertheless, whenever it is used, "Superwoman" implies a narrative about limitation, oppression, and potential exhaustion. You only seem to earn the "Super" label if you are not only *able* to do it all superbly, but if you *have* to do it all.

I now hear my students speak in a rhetoric of "combining" career, relationships, and motherhood. Their language is very foreign to me, although my life includes all these elements. I don't think of life,

though, as "having," but as being and doing, above all as changing and making change. What I like about trying to merge the Amazon and the mother is that it helps to bring together the power we have been barred from and the (potential) power we have been restricted to. But even this degree of metaphoric "combination" may be too static, for I think Wonder Woman functions best as an ongoing story we tell ourselves, not a manageable goal. And that, too, makes me wonder. . . .

Perhaps the most striking aspect of this article, as I read it now, thirteen years later, is how little it says about Wonder Woman. In that sense, what I have been remembering and describing as my first piece of comic book criticism is not really that at all. Rather, it privileges the cultural studies dimension to the point that Wonder Woman might almost be a *symptom* of the social forces that created her and, even more, the (socially informed) desires that I brought to the act of interpretation. What I think keeps this essentially clinical note from being the dominant one is the attention to tradition. Although the ancient myths that gave us Wonder Woman's tutelary goddesses and the figure of the Amazon are accorded relatively short shrift in "Looking for Wonder Woman," later representations of women's military and maternal power are discussed in ways that make it possible to tease out social and cultural themes.

Part of the reason for reference to early modern mythologies is personal: It was only in 1989, when I wrote this article, that I recognized that my early comic reading was a source for the dissertation on the female knight in sixteenth-century epic for which I'd received the doctorate with distinction fifteen years earlier and which had been published, somewhat revised, only four years earlier (Robinson 1985). Well, I've already said "Duh!" haven't I? I continue to believe it is important to explore the connection between female superheroes in the comics and the variations on and departures from ancient myth that have emerged in the roughly two millennia between, say, the composition of the New Testament and the day before yesterday.

This is a period definition deliberately made broad enough to encompass medieval Mariolatry, Renaissance epic, and whatever subsequent goddesses or warriors emerged at any time in postancient history up until World War II. As my remarks in the Preface suggest, however, this book also takes a longer look at the older images, the ways that the superheroes resonate with ancient myth, particularly the ways that the mythic appropriations have nonetheless left the comics free to perform drastic rewritings far more thoroughgoing than the high-culture adaptations of those same myths practiced by white male inheritors of the Western cultural tradition.

Unlike the article, the book attempts a reading of the comics themselves, looking first, of course, at *Wonder Woman* and extending the interpretation to her early imitators and thence to later generations of female superheroes. This entails identifying (and in some cases, giving names to) the conventions of the genre, acknowledging that a comic book is a comic book at the same time that it is a reworking of classical myth or a commentary on contemporary society. Before we can understand how, for instance, Wonder Woman deals with Nazism or Invisible Woman with cyberconspiracy, we must have a sense of how comic books construct the idea of the enemy and the central combat the hero wages.

The comics also rely on visual conventions, which may support the narrative (after all, we can see as well as "hear" the *POW!* that strikes a blow for the side defined as the right one), but which also have a history and significance of their own. Although "Looking for Wonder Woman" was commissioned by a magazine oriented toward the visual arts, it does not treat the comics as an art form in themselves, one influenced by and eventually influencing developments in both "high" and commercial art. If such consideration is overdue in the discussion of the comics as a genre, its absence is even more salient when it comes to the representation of female superheroes, where the evolution of the hero's body is a significant visible part of the history and where the contradictions, at certain periods, between visual and

narrative information about gender reflect tensions—"growing pains," perhaps—over the issue.

If "Looking for Wonder Woman" does not introduce much in the way of reading *Wonder Woman,* it does lay the groundwork for looking at the female superhero in a cultural context, including the presence of feminism as one element of that context. The article situates the search in a society whose every facet has been interrogated and in some way touched by the feminist challenge to received ideas about women and gender. So feminism is not only the way I read, but also a subject of the comic book texts I am reading. *Wonder Woman* did pioneer a kind of feminist questioning, however commercially packaged and conceptually limited, at a time when few other voices in American society were raising such questions. But, for more than half of Wonder Woman's long life, intersected as it has been by the creation and flourishing of other superheroes, there has been an activist women's movement that is part of both the realistic and the mythopoeic landscape in which the narratives unfold. Part of the critical task, therefore, is to consider the extent to which the comics have and have not embraced and taken off from new possibilities.

Cultural studies, by definition, looks at a particular work or form as a product of the surrounding culture. Connecting a narrative to the dominant (or sometimes, for that matter, the latent and resistant) forces in society is perhaps the most obvious part of the critical mandate, and too many commentators stop at this point. But there are other places outside the text that inform it and that should inform a cultural reading. One of them is the interaction between the reader and the text. In "Looking for Wonder Woman," I reflect on the way that my own rejection of the superhero's Diana Prince identity and its implications shaped the text I read. On one level, I was perpetrating a misreading, a distortion, while, on another, I was creating a new if related experience. At the same time, the text had an influence on me, and that effect on the mass audience, however much, as individuals, we may have used and transformed what we read in the comics, also

demands serious scrutiny. (If I didn't have good reasons for sticking with my biblically inspired section titles, perhaps I could call such a chapter "See *You* in the Funny Papers.")

The other force that, operating from outside the text, is very much a part of what's inside, is the industry itself. The sociology of any art form entails study of production, patronage, and consumption. These affect everything from whether a work ever comes into being at all to whether and how it is recognized in its time and has the possibility of surviving into the future. Cultural studies sometimes—regrettably—treat these matters as if they were big revelations, especially when it comes to popular culture. Because mass culture exists primarily to make money, because its artists are also employees, and because mass *media* reject responsibility for shaping either taste or ideology (falling back on the redundancy that they "only give the public what they want"), it is easy to err in the other, positivist direction. In fact, though, it is—and damn well should be—impossible to discuss the comics without recognizing that the commercial enterprise that makes and sells them is part of the figurative if not the literal picture.

Why have I returned to the superheroes after such a long time—more than five decades, if we think of my period of heaviest comic book reading, thirteen years, if we count from "Looking for Wonder Woman"? Again, the answer is in my experience as a reader. The other book on which I am working, *Mixed Company: Mythologies of Interracial Rape,* scheduled by Routledge for publication in 2005, requires me to read a great deal of very painful material. One thing that helped me do it was turning from descriptions of lynchings to representations of Wonder Woman kicking ass. It didn't make the horror go away, but it enabled me to go back to it.

More than forty years ago—measured in this reader's subjective time, somewhere between *Wonder Woman* and the Italian epics—I had a brief and otherwise forgettable relationship with a man who called me "Lilith" as an (I think) affectionate variant on my name. I liked it at the time, because it signified transgression— multidimen-

sional and insistent desire. Maybe, though, Lilith was not the ardent twenty-year-old English major who was given the name, but the little girl who rejected the story on the page, choosing tangible, visible power over self-abnegation and secret strength. Lilith, the one in the largely unwritten myth, was annihilated (where did she go?). She was replaced by Eve, who was no stranger to transgression herself, but whose transgression did not go off in all directions, like Lilith's in the infancy of the world in a discursive universe where the etymology of "infant" lies in not speaking. Rather, Eden was this world's *child-hood*, where the chaos was organized by naming, by language, and the transgression was more focused. In fact, just as Eve is called the first woman, her sin, the ingestion of knowledge, is called the original one. So perhaps it is no accident, after all, that she appears in Genesis and that I have appropriated that name for the first section of this study.

Notes

1. It turns out my fears had a more sound historical basis than the general ethos of the '50s. Wonder Woman and I were both born in 1941. Her creator, William Moulton Marston (who signed the comic books as Charles Moulton), had a radical feminist belief in the power of female love versus male violence and devised his kick-ass heroine as an activist who could force evil to destroy *itself* "unless Wonder Woman can bind it for constructive use." After Marston's death, in 1948, the comic book was continued by male artists who did not share his ideological perspective, and it began going rapidly downhill (Edgar 1972, 52–55).
2. For another interpretation of the relationship between worship of the maternal principle and women's actual social power, see Riane Eisler's *The Chalice and the Blade* (1987).
3. On the Renaissance women warriors, see Lillian S. Robinson, *Monstrous Regiment: The Lady Knight in Sixteenth-Century Epic* (1985). Chinese legends of the military female have entered Western literary consciousness through Maxine Hong Kingston's 1976 memoir *The Woman Warrior*.

Three

Genesis
Departing from Paradise

IN THE BEGINNING there was *Wonder Woman*. And, in the beginning of *Wonder Woman*, there was feminism. In 1941, the Amazon hero's originator, Charles Moulton, pseudonym of psychologist William Moulton Marston, was determined to create an alternative to the violence that characterized the male-dominated and naively masculinist adventure comic books that were then popular (Edgar 1972, 52–55; Steinem 1995, 8–10). Taking the position that women were by nature less combative, inclined toward peace and nurturance instead of war and domination—a version of feminism that we would now characterize as "essentialist"—Moulton invented Paradise Island, where the future Wonder Woman grew into an athletically and militarily able Amazon princess, and enlisted his female superhero on the Allied side in World War II.

The origins story as Moulton devised it has two distinct stages, however: the creation of the Amazonian utopia on Paradise Island, and the emigration from Paradise of Princess Diana, whose powers were rapidly to earn her the sobriquet "Wonder Woman." As recounted in *Wonder Woman Comics* 1, no. 1 (Summer 1942):

> Wonder Woman's story is the history of her race. It reaches back into that Golden Age when proud and beautiful women, stronger than men, ruled Amazonia and worshipped ardently the immortal Aphrodite, goddess of Love and Beauty.

> Out of that legendary glory, which present day Amazons still pursue
> in secret, comes Wonder Woman, the most powerful and captivating
> girl of modern times, the fearless maiden who gave up her heritage of
> peace and happiness to help America fight evil and aggression.

These words appear on a scroll suspended in the introductory frame, which shows Princess Diana, still wearing the Amazon uniform, at the moment of victory over another Amazon whom she has thrown from the saddle and holds helpless at swordpoint, while the identically clad women who throng the arena cheer her on. Text and picture represent two key moments in the creation: Amazonian survival and enlistment in the American cause. Together, they prepare the reader for a longer historical elaboration, which begins on the next page, when one of Captain Steve Trevor's doctors takes a fragment of ancient parchment to the Smithsonian for interpretation. By this time, the reader has seen Steve, the "brilliant young officer in the Army Intelligence Service" crash and disappear, be written off for dead, and then be returned to a military hospital by a beautiful girl who rushes off, dropping the revelatory parchment as she flees. Although, refusing further identification, she says, "I'm just—a woman," from his bed of pain, the heavily bandaged Trevor expands this and rechristens her "My Wonder Woman."

So, in the first instance, it is her capacity to heal, rather than to fight that is responsible for the superhero's name. The scene flows into the "history of the unconquerable Amazons" as the "ancient script" relates it. For the world was ruled by two rival deities, Ares, god of war, and Aphrodite, goddess of love and beauty. Because women are the enslaved victims of Ares' masculinist warfare ("My men shall rule with the sword," he proclaims, while Aphrodite responds, "My women shall conquer men with love"), the goddess shapes "with her own hands a race of super women, stronger than men" and endows them, as well, with the queen's magic girdle, which renders them invincible.

And so they remain, until Hercules, leading the Greek foes of Amazonia, seduces Queen Hippolyte with wine and flattering love

talk ("woman's own weapon," we're told) into letting him hold the girdle. In the ensuing debacle, the Amazons are chained and imprisoned, their city looted. But Hippolyte prays to Aphrodite for forgiveness of her "sin" and help in the women's plight, and a second chance is vouchsafed. The chains are broken, replaced by bracelet-reminders of "the folly of submitting to man's domination," the Amazons fight the Greeks, Hippolyte recovers her magic girdle, and, victorious, the women sail "far seas to their promised haven of peace and protection," where "on Paradise Isle they built a splendid city which no man may enter—a Paradise for women only."

Whoa! Five pages into an epic whose text has continued to roll off the presses for more than six decades, now, we are not only on Paradise Island, but also in extraordinary (and extraordinarily daring) territory—at least from the perspective of the Greek myths whose gods and heroes have been appropriated to tell this new story. Moulton's Olympians, first of all, possess powers the Greeks never gave them, since they have apparently been liberated from the overarching rule of the father, Zeus, and of destiny itself. They can bestow superhuman gifts and, unlike their namesakes in ancient myth, can even create life. At least, Aphrodite can do both, although Hercules has to resort to a base stratagem to get his hands on that girdle, since Mars apparently cannot use his own divine capacity to make a superior offensive or defensive weapon.

It is not clear just how the goddess creates her mistress race. She is depicted in front of a group of full-grown women into whom she may (or may not yet) have breathed life. The Olympians famously reproduced through more familiar heterosexual means, marital and distinctly extra–marital, with other deities and with humans, and in various temporary disguises, as well as in their own numinous forms. For an audience of children who very likely know something about *a* divinity, the one in Genesis, who created Eden and its sentient occupants ex nihilo, Moulton invents a female deity who has the power attributed to the God of Genesis, rather than to any member of the Pantheon to which Aphrodite belongs. The comic book goddess is the

mother of a race, but she does not have to experience conception or birth to assume the role. In this sense, she is even more powerful than the Great Mother whose worship preceded the cult of the Olympians and who survives in a paler form as the Greek Demeter or the Roman Ceres. This Aphrodite has and needs no lover, for motherhood or for pleasure, and nothing remains but the names to remind the reader that the "real" Aphrodite, the one in all the ancient stories, had an adulterous love affair with the god of war (and wasn't he her half brother, by the way?).

In the dialectic inherited from the two Homeric epics, traditional adventure comics are definitely "Iliadic," focused on the war story, rather than "Odyssean," focused on the hero's internal and external journey. (The case could be made that, with Marvel Comics, the genre acquires an Odyssean dimension. I'm not sure I am prepared to make such a case, but, in any event, that evolution is more than twenty years beyond the stage this history has reached.) *Wonder Woman* shares with its contemporary comics the Iliadic approach to events, but its home base on Paradise Island is reminiscent of Odysseus's insular landfalls. Here, however, the denizens would never have let Odysseus set foot, much less tempt him and his crew to either shipwreck or shack up.

More important, in Moulton's epic origins story, the Greeks are the unequivocal enemy; their culture is one of patriarchal violence, without any of the other qualities we have been taught to associate with it—including the production of classical mythology and the literature that elaborates it. If this is "civilization" or culture, *Wonder Woman* is telling us, we women want no part of it, because we *have* no acceptable, no honorable part *in* it. Aphrodite, who has become much more important than she is in the Hellenic or Roman scheme of things, is apparently one of the few original elements worth preserving, while not only Ares, but the heroic Hercules, are firmly moved to the debit side of the cultural ledger. As for Amazons themselves, always understood in Greek mythology as the adversary that has to be subjugated in order for Greek values to prosper, well, once those val-

ues have been reduced by Moulton to those of the vulgar bully Ares and his henchman Hercules, the former enemy-by-definition can become the hero. (Actually, although the Amazons are represented in Greek myth as barely human barbarians, their subjugation to Athens *is* associated with tragedy; it's just not the Amazons' own tragedy that is recognized and allowed to take center stage.)

As I say, that's a lot of rewriting for five pages, completely reversing the categories of good and evil, civilization and barbarism, and, by no means incidentally, male and female, as the Greek sources delineate them and the Roman ones elaborate and extend them! There is a faint hint, moreover, of another mythological source, the Old Testament, as Aphrodite exercises her life-creating power. This hint is broadened as the origins story continues, for, the Ur-*Wonder Woman* goes on, once established on Paradise, the queen, under the direction of Athena, goddess of wisdom, learns the secret of molding a human form. (The parchment's contents now exhausted, the rest of the origins narrative, we are told, relies "on later sources of information." In short, the agon between Ares and Aphrodite and the foundation of an Amazonian Paradise are "true" ancient myths, whereas the birth of the hero—our own female superhero—is essentially acknowledged as a modern invention!)

What happens is that, under Athena's tutelage, Hippolyte makes a model of a girl child. The medium looks like clay. Then, seemingly because Hippolyte "worships" the image she had made, much as Pygmalion worshiped Galatea, Aphrodite, the true Creator Spirit, comes along and grants the queen her prayer, by "bestowing the divine gift of life on it." It is also she who, slipping casually into the Roman version of the Pantheon, names the child Diana after the goddess of the moon and the hunt. The newly animated wonder child, by no means a baby, leaps into her mother's arms and proceeds, through the next several panels, to exhibit remarkable athletic prowess, as she grows to the nubile age at which she acquires her superhero identity.

So here we have what amounts to a special creation, mirroring the one in Genesis, in which a human being is fashioned out of earth.

Only here it is decidedly not the creation of man, but of woman, with no spare rib intervening. And, although it is the goddess alone who has and deploys the powers that make the image live, it is the mother who has molded the physical child, just as she will "mold" her character, once she becomes a living, breathing person. This also answers the question I posed in "Looking for Wonder Woman." There never *was* a father—on earth or in heaven. This is an interesting revision, since Hesiod tells us that Aphrodite herself arose from the sea, which had been impregnated by a stray bit of the divine patriarch's seed, and Zeus carried Athena to term after her mother's demise, whereas there are no Greek myths about a mother's doing it alone from the git-go.

When Princess Diana, now religiously dedicated to Aphrodite in the comics/pagan version of a confirmation ceremony, reaches marriageable age (not that there is any marrying or giving in marriage in Moulton's Paradise), the world is at war. The world, that is, exclusive of Paradise Island, which is unknown to outside cartographers. Ares, the readers learned a couple of pages back, is "now" known as Mars, and it is under this name that he childishly taunts Aphrodite: "Ho! Ho! The whole world's at war—I rule the earth!" Her reply is prompt and confident: "Your rule will end when America wins! And America *will* win! I'll send an Amazon to help her!" Readers in 1942, presumably preadolescents steeped in the adventure comics worldview, were not supposed to find this pathetic or ridiculous. Kids whose fathers, uncles, and older brothers were already in uniform, whose mothers, aunts, and older sisters had taken war production jobs, who were themselves collecting scrap and buying war-loan savings stamps or planting victory gardens were being taught to think of the war as a collective effort where each individual's contribution was essential. So why *not* an Amazon to turn the tide decisively our way? In any event, a great deal of war propaganda was and is based on the adventure-comics mentality, and the older DC superheroes had already enlisted. The Green Hornet's houseboy, Kato, had even obligingly changed overnight from Japanese to Filipino, so, again, why not an Amazon fighting America's good fight?

Aphrodite's wartime message may be simplistic, but it also adds feminism to the standard United Front line. This was by no means unique to the comics. Films and print advertisements encouraging women to engage in war service played on two themes; although the more frequent chord called upon women to support their male loved ones by participating in the national effort, the other strain reminded them that fascism entailed the destruction of women's rights. It is in this vein that the goddess of love and beauty, accompanied by Athena, urges Hippolyte to deploy an Amazon to assist the cause of America, that "last bastion of democracy and equal rights for women."

Princess Diana wants to be the Amazon selected for this service, but her reasons for wishing to leave Paradise—and thereby, seemingly, to give up immortality, as well—have little to do with last citadels of democracy, much less with equal rights for women. Quite the contrary, she has fallen in love with Steve Trevor, the Army Intelligence pilot whose plane did not disappear into the ocean, as his superiors assumed, but crash-landed on Paradise. And it is she who has developed a healing ray—it sheds a "weird purple light"—that not only effects his cure but that begins its work by bringing him back from death, the fate the experienced Amazonian doctor has already announced to be his.

It is worth a digression to inquire what the doctor's experience of death actually is. There does seem to be a generational difference among the inhabitants of the island, yet Hippolyte is the same queen originally chosen for that office and the guardianship of the magic girdle when the Amazons were first created, so she has lived for millennia, and the fate of her original companions goes unmentioned. For a long time, the mystery—and it is, after all, the greatest of all the mysteries, that of life and death—was no closer to resolution than when I first wrote about the apparent coexistence on Paradise of immortality and natural reproduction. Just as with my speculation before I realized that Princess Diana's conception took place in the atelier, rather than the bedroom, it made no consistent sense either way and clearly looked like a logical question no one is meant to be literal-minded enough to ask.

It turns out that there are not only two stages to the origins story, but, as in Genesis, two creation narratives. The character of Wonder Woman, her origins on Paradise Island, the long history of the island's Amazon civilization, the arrival of Steve Trevor, and all the rest of it initially appeared in DC's *All Star Comics* (no. 8, December 1941–January 1942). Her subsequent adventures were then recounted, with frequent reference to the origins story, in *Sensation Comics,* whose first issue was dated January 1942. (Given the post-dating typical of the genre, this suggests at least a month between the appearance of the two publications, rather than an overlap. What happened in that month, of course, is that Pearl Harbor was bombed and the United States entered World War II.) Volume 1, no. 1 of *Wonder Woman Comics* did not appear until the summer issue of 1942, whose version of the myth I cited earlier. Thereafter, for several years, the young Amazon's feats continued to cause a monthly *Sensation,* as well as occupying "her own" bimonthly magazine.

Since Charles Moulton was responsible for the texts of both comics and Harry G. Peter was the artist in charge of Wonder Woman's literal image, there was almost no discernable difference between the two venues. Having two magazines simply made it possible for more Wonder Woman stories to reach the public. (The Justice League was to provide yet another site for Wonder Woman's powers to be deployed.) I say almost no differences advisedly, because there is the little matter of life and death—the immortality question. In the first three issues of *Sensation Comics,* the initial reference to the immortality of the Amazons on Paradise Island is repeated. A typical first-page summary from an early *Sensation* comic (February 1942) speaks of Paradise Island as a place "where life is eternal, where sorrow and suffering are unknown, and where love and justice make women powerful beyond the dreams of men."

Such descriptions were subsequently replaced by reference to the "mysterious" nature of the superhero's island home, along with a formulaic comparison that attributes to her "the beauty of Aphrodite, the wisdom of Athena, the strength of Hercules, and the speed of

Mercury," and it is "merely" beauty and peace that she is said to have abandoned to come to America. An allusion to the actual condition of contemporary women is added to the superheroic encomia in *Sensation* no. 7 (July 1942), where Wonder Woman is described as "defending America from the enemies of democracy and fighting fearlessly for downtrodden women and children in a man-made world." Once immortality is excised from the text, we continue to be reminded that Wonder Woman is the queen's daughter, but there is not yet any indication of how Hippolyte happened to have a child in a man-free environment.

In Wonder Woman's first *All Star* appearance, the origins of the Amazonian Paradise are narrated in type-heavy columns interspersed with illustrations somewhat smaller than the standard comics frame, and the arrival of Steve Trevor is elucidated by the queen's Magic Sphere. (It is this Sphere, the gift of Athena, that enables the Amazons to "know what has gone on and is going on in the other world, and even, at times, to forecast the future.") Hippolyte attributes her own and her culture's achievements to this Magic Sphere, explaining to her daughter that it

> is why we Amazons have been able to far surpass the inventions of the so-called man-made civilization! We are not only stronger and wiser than men—but our weapons are better—our flying machines are further advanced! And it is through the knowledge that I have gained from this Magic Sphere that I have taught you, my daughter, all the arts and sciences and languages of modern as well as ancient times!

By mid-1942, when the eponymous bimonthly was introduced, immortality had not been mentioned in the Wonder Woman narratives for some months (the theme was rather brief, as eternal life goes!) and the origins story was repeated with a new twist. It is here, along with a somewhat different version of Steve Trevor's crash-landing, that, parallel to the creation of the Edenic universe itself, there is the classic myth of the birth of the (super-) hero, represented as an act

of divinely authorized sculpture. As far as I know, this part of the narrative was not reiterated, unlike the origins stories of Superman and Batman, which periodically brought new readers up to speed on a serial they were entering in medias res. In subsequent early issues, however, there is a suggestion that the reproductive miracle was repeated, so that there are other little girls and adolescents on Paradise. The remaining incongruity is the apparent longevity of Wonder Woman's mother the queen, which coexists with the implication that, superpowers or no, Wonder Woman herself can die. (Indeed, the mechanical limitations of her powers lead her with amazing frequency into situations where she tempts fate in the form of an onrushing train or a deep-sea burial and narrowly escapes being killed.)

By the time *Wonder Woman Comics* had been publishing for a year and a half (no. 7, Winter 1943), the false trail of immortality had been so successfully covered over that two stories in the same issue could be set in the early years of the fourth millennium. Consulting the Magic Sphere with her mother to learn about the status of women more than a thousand years in the future, Wonder Woman is not surprised to learn that, as an Amazon, she will be around to enjoy a world where women are finally in charge everywhere as they are on Paradise Island. We learn why, as *she* learns how it will come to pass that her non-Amazon friends, the Holliday College girls first and foremost, but also Steve Trevor and intelligence boss Colonel (by 3004, General) Hartnell, will also survive, still youthful looking, to be part of the new order.

It seems that, a few decades after the narrative's present tense, Etta Candy is driven by desperate grief at her eighty-two-year-old mother's failing health to "study chemistry night and day" in the hope of finding a cure for the aging process. It's all to no avail, however, until Wonder Woman produces a golden flask containing "water from the fountain of youth on Paradise Island." She speculates that the water might do some good, although "Aphrodite's life vitamin affects only Amazons." (Aha!) At the last moment, Etta adds some candy (homeopathic medicine since her mom's name is Sugar

Candy?) thinking "it might release Vitamin L-3." In fact, it pulls the white-haired old lady back from beyond the frontier of death and turns her into a young, lively blonde who leaps out of bed eager to go dancing. As Wonder Woman explains it, the elixir's magic worked because "the dextrose in the candy liberated hydrogen to form an organic compound," concluding, "By the great club of Hercules, we've isolated the life vitamin!" In the frame following her mother's resurrection, we see Etta, in cap and gown, receiving a "grand international" award for her remarkable scientific discovery. During the presentation, she is identified as "Professor of Public Health at Wonder Woman College."

In the rest of this episode and the next, which take place in the extended fourth millennium life of Etta, Steve, and both of Wonder Woman's avatars, Etta's costume alternates between her red and white Holliday gym outfit and the mortarboard and attenuated robe she'd worn for the awards ceremony a thousand years earlier. She wears the gym shorts for her public appearances as Diana Prince's running mate in the 3004 presidential election, but has covered it with the academic regalia when she "explains" why Wonder Woman will recover from being frozen in liquid air by the macho counterrevolutionaries: "When a living body is frozen very quickly it does not die immediately but remains in a state of suspended animation! How long it'll live depends on the strength and vigor of the person frozen. Wonder Woman'd live for a year, I betcha!" So, in addition to the life vitamin, Etta has already done some research on cryogenics! At any rate, instead of immortality being a racial given for the Amazons, longevity is a reality for them and a possibility for other, normal humans, through the conjoined (and typically comic book) operation of magic and science.

Whether or not Diana consciously gives up immortality to accompany Steve Trevor from the goddess's country to God's, her feeling for him is represented as being strong enough to make this conceivable. Before the recruitment call by Aphrodite and Athena, the princess was denied permission to fly Steve home in her "new invisible plane," and her mother tries to bar her from the contest that

will determine the lucky Amazon allowed to join the U.S. forces. Hippolyte's attempts to protect her daughter—not from military service, to which she is quite ready to commit an Amazon warrior, but from the perils of loving a man—are doomed to failure, as Diana enters the successive skills contests masked (although any child could easily recognize her) and triumphs even in the final round, the breathtaking display called "Bullets and Bracelets." It remains only for her to receive the flag-patterned costume her mother has designed, drop Steve at the hospital where he inadvertently names her "Wonder Woman," and find a uniformed woman—army nurse Diana Prince, as it turns out—eager to turn her identity and military duties over to the mysterious stranger, and she is in business—superhero business.

Throughout the rest of World War II, Wonder Woman fights the good fight, combating espionage and subversion, even threatened terrorism, and generally kicking fascist butt. She takes on the entire Axis, at one time or another. In *All Star*'s inaugural Wonder Woman issue, the saboteurs who send a drugged Steve Trevor up in a robot plane to strafe an American base—assuming he will crash while still unconscious, rather than achieving Paradise—are Germans. Like all of Moulton's Nazis, they are stereotyped Prussians who speak with vaudeville accents and insert the (very) occasional Teutonism into their speech. ("Donnerwetter!" they may exclaim, or substitute "der" for "the," regardless of the gender or number of the noun that follows.) Like Roberto Benigni's deliberate mischaracterization of the concentration camp guards in *Life Is Beautiful,* they are "mean guys who yell." By contrast, the "Japs" (invariably so-called in the Wonder Woman narrative, as indeed they were without self-consciousness in all U.S. pop culture of the war years) tend to hiss their accented English. But Nazi and "Jap" techniques of evildoing are otherwise indistinguishable. Italians do not appear often enough for a stereotype to emerge, but Mussolini himself does come into one story and, in another, an Italian count with espionage on his mind courts a rich American girl in the guise of a *Spanish* aristocrat. (That Spain was also fascist, although nominally neutral in the international conflict,

seems to have escaped Wonder Woman's creator, or at least was a fact he did not expect to weigh heavily with his youthful audience.)

Many nationals of other countries—I can think of an Austrian, a Mexican, and a Chinese—are forced, often by blackmail involving the safety of a loved one, to do the dirty work of a German or Japanese master, but few people are evil enough to be working with the enemy voluntarily. Some exceptions include "greedy" American businessmen who corner the market in an essential commodity (milk, in one instance) or function as a cartel to control another (rubber). And, in one memorable case (*Wonder Woman* no. 2, Fall 1942), the president of Holliday College, home of Wonder Woman's band of helpers, does away with the institution's treasurer in order to bankrupt Holliday, which will enable the Nazis to use its newly deserted campus to store a stolen gold shipment. For anyone familiar with present-day universities' capital campaigns, the sum needed to keep Holliday's doors open sounds an unintentionally ironic note. The defalcation amounts to $50,000, although, as Etta Candy lugubriously maintains, "Woo! Woo! Might as well be a million!" And, once Prexy Deacon is unmasked as the Nazis' tool, Wonder Woman joins the Holliday baseball team in an exhibition game against the World Series winners (owned, by the way, by one Jake Dough), with the college's share of the gate coming to $102,739. And so higher education, comic book style, can proceed.

In this episode, the gold stolen from America by the Nazis was to be loaded onto a "Martian" spaceship for delivery to the Earl of Greed, one of the war god's three titled accomplices, the others being the Duke of Deception and the Count of Conquest. It is these three who, employing the particular evil from which their respective names derive, serve as the conduits between Mars and the Axis. This narrative originates with Mars's insistence that Wonder Woman be captured and brought to him in chains. Conquest refuses the job, on the grounds that fighting a "mere woman" is beneath him, while Deception explains that his minions, his "best liars and deceivers" are all busy churning out "Nazi and Jap propaganda." The task, therefore,

falls to the Earl, who exhibits greed himself and instills it in Hitler, whose agents then use it against the ironically named Deacon.

The chain of evidence is not quite as clear as I have represented it, because Hitler is depicted as too much of a madman to be influenced by any single motive. Mars's agent NZ-1, as Der Führer is known, receives a "mental radio" message from Greed that interrupts his "meal" (he's chewing on quite a large bite of green carpet at the time it comes through) and forces him to change his mind about attending the gestapo meeting where new evil plans are hatched. Apparently, by that point in the war, the notion that the Nazi leader's fits of rage caused him to "chew the rug" was not only so widespread that American children would be familiar with it, but was taken so literally that they would recognize the ludicrous image of carpet munching for what it was meant to convey.

This episode makes it clear that, by the time Wonder Woman got her own magazine, her relationship with the Holliday students was already firmly established—both as a recurrent plot device and in the regular readers' minds. Although Steve Trevor as comrade-in-arms or valuable intelligence asset in need of rescue recurs in every early issue, in the undergraduates of all-female Holliday College, Wonder Woman also acquired, early on, a stateside substitute for the Amazon band. My undoubtedly schizophrenic reading (or was it simply postmodern *avant la lettre*?) not only shut out the Diana Prince sequences, but also cast a shade on those featuring the "Holliday girls." I found them silly and gushy, girlish in a stereotypical sense. They embarrassed me, threatening the same fragile protofeminist foundation menaced by the Diana-Steve segments, which would suggest that it wasn't so much the romance theme that alarmed me as a general limitation of female character and possibility.

Ancient narrative and visual representations usually show the Amazons as acting in community, tribally, a fact that exponentially increased the awe that their power and their challenge to the female norm inspired—as well, of course, as multiplying the kind of threat they represented. Although Wonder Woman is distinctly one of a

kind, she also has "the girls" to assist her. And even more than the kick-ass power itself, it is this female collectivity that led Frederic Wertham, whose Freudian critique of the nefarious influence of the comics on impressionable young minds strongly influenced the creation of the industry's regulatory Comics Code, to stigmatize Wonder Woman as a lesbian. I use the word *stigmatize* advisedly, for, as I indicated earlier, Wertham considered such a representation a "frightening image" for boys to encounter, a "morbid ideal" for girls to emulate (Wertham 1953, 193; see also Feiffer 1965, 44).

Still, for Wertham, the problem with lesbianism does not reside in identity so much as in relationships. So even what he sees as a persistent "antimasculine" attitude on the part of Wonder Woman and her counterparts (he also devotes a censorious paragraph to Black Cat) pales beneath the horrors suggested to him by the band of undergraduate followers. From his perspective, even the name of their college overdetermines the situation, for he extrapolates the "Holliday girls" to "the holiday girls, the gay party girls, the gay girls" (193). It is not clear from this whether Wertham expected the general reader to understand the homosexual connotations of "gay," which was still largely an underground code word in 1953, or whether part of his indictment of lesbianism relied on the "gay" women's frivolous rejection of the womanly role. A case in point, not one that Wertham cites—although if he found the Amazonian allusions "frightening," this one would evoke terror—occurs in the first issue of *Wonder Woman*. Diana Prince chides Etta Candy about her weight, stressing that too much candy is unhealthy, bad for the constitution. When Etta rejects this argument by quipping, "My constitution has room for lots of amendments," Diana pleads, "But Etta, if you get too fat you can't catch a man." Etta's reply is categorical and seemingly free of double entendre: "Who wants to? When you've got a man, there's nothing you can do with him—but candy you can *eat*!"

The rest of Wertham's "frightening" and "morbid" representation has to do precisely with the band of women *as* a band, an adventurous one. "They are all," he complains, "continuously being threatened,

captured, almost put to death. There is a great deal of mutual res-
cuing, the same type of rescue fantasies as in Batman" (193). But,
whereas the concern that Batman and Robin show for one another, as
reflected in repeated rescues, strikes Wertham as reflecting, as well, a
perverse and unhealthy attachment, it is as if, for the gang of "gay
girls," the "mutual rescuing" in itself constituted a recognized form
of sexual deviance.

Unsurprisingly, Gloria Steinem draws a quite different conclusion
from the mutuality of the rescuing as signaling "Wonder Woman's
ability to unleash the power of self-respect in the women around her,
to help them work together and support each other." The psycholog-
ical implications of this female bonding would presumably not trou-
ble her as they did Wertham, but the real point is that she reads it as
psycho*political*. She thus concludes that the "discovery of sisterhood
can be exhilarating indeed," pointing out that what women get from
the narrative is "a rare message of independence, of depending on
themselves, not even on Wonder Woman. 'You saved yourselves,' as
she tells the girls in one of her inevitable morals at story's end. 'I only
showed you that you could!'" (qtd. Steinem 1995, 14).

The chief attribute of the far from Amazonian Holliday students
is loyalty—to the group (sisterhood represented as undergraduate
sorority), to Wonder Woman herself, to their college, when the need
arises, and to their country. Their unquestioned solidarity makes it
possible for them to carry out (and occasionally even to initiate) the
elaborate schemes required for the "mutual rescuing" Wertham so
fears. (The rescuing, by the way, is not invariably mutual and same-
sex. In one of the earlier episodes, the one that contains the discus-
sion of candy as diet, it is Etta Candy's soldier brother, Mint, who
needs help.) The Holliday girls are equipped with at least some of
Wonder Woman's state of the (comic) art communications technol-
ogy, but they do not have access to the rest of her arsenal.

Since the majority of *Wonder Woman*'s readers were boys, it is
not clear whether, beyond figuring as a latter-day Amazon band, the
Holliday girls are meant as surrogates that allow the reader to enter

the story vicariously. But, given the childlike representation of their leader, Etta Candy, who is babyish in her irrepressible desire for sweets and is also chubby and notably short and who sometimes wears skirts abbreviated enough to show her little-girl bloomers, they could almost fill the function of the child sidekicks with whom so many contemporary comic book and radio heroes were endowed. (It's the motif that James Thurber hilariously parodied in his essay "Thix.")

If Wertham was hypersensitive and politically retrograde in his treatment of the homosexual theme he detected or thought he detected in the Wonder Woman narrative, he was apparently oblivious to the sadomasochistic and bondage elements that strike today's reader as clamoring for notice. The Holliday girls are the focus of much of the S and M, since they are freer than Wonder Woman, in either of her avatars, to enact fantasies of blindfolding, arbitrary tying up, and promiscuous spanking. Not for nothing is the Greek letter in their sorority's name changed so that the name itself reads *Beeta Lambda*. Sometimes, spanking is seen as part of a much-relished initiation ritual, sometimes the initiation gear is used to torture a suspect left in Holliday custody, and sometimes a public struggle with a spy is explained to the authorities as part of a sorority rite. The girls even use their paddles on men, occasionally, if those are the only weapons at hand, and they direct planks of wood and other devices to their adversaries' derrieres. Wonder Woman herself, however, practically never interprets spanking as good, clean fun. On the occasions when she is threatened with it—with a tennis racket, say—the infantilization and humiliation she associates with it goad her to further, always successful resistance.

All told, my childhood dismissal of the Holliday girls was figuratively as well as literally premature, inserting a blind spot just where there should, at the very least, have been a tissue of question marks. They may be on perpetual holiday, but the girls are, at one and the same time, an Amazon band and a marching band, comic relief and pointers to some very serious sexual issues—where "vanilla" lesbian

identity and relationships do not seem to figure very strongly. They are childlike, but capable of mature planning. And Etta's oral fixation—the candy fetish—replaces more than heterosexual fulfillment. It is an obsession, an addiction, almost a religion in itself, and, along with Etta's obesity, must have sent a welcome subversive message to children to whom adventure comics typically preached a superhero morality based on rigid, ascetic bodily training and self-denial. This theme even comes across in the comics' representation of unfulfilled heterosexuality, to which the Holliday girls serve as a tantalizing counterpoint. With this notable exception, moreover, the grotesque body is associated, in the DC world—including *Wonder Woman* (cue Dr. Psycho)—with villainy. Superheroes are also superattractive. Marvel was to introduce grotesque male heroes, but the females remain uniformly beautiful.

In addition to her all-girl backup squad, Wonder Woman had plenty of female enemies—notably Paula, Baroness von Gunther, and the socialite Priscilla Rich, whose villainous alter ego is the Cheetah. Both of these, presumably because they are women, are open to redemption. The Baroness turns out to be one of the Nazis' blackmail victims, doing their bidding only because they are holding her child hostage, and, once Wonder Woman rescues the little girl and places her in school on Paradise Island, Paula, as she is henceforth known, is prepared to divert her superb intelligence to the Allied side. Priscilla Rich, by contrast, suffers from low self-esteem (this was not yet a pop-culture byword in the early 1940s, but she's got a bad case of it), so she constantly backslides into her Cheetah identity, but, although the road is a rocky one, she is clearly capable of rehabilitation and redemption.

Not so the male villains, including not only Mars himself but his henchmen the Duke, the Count, and the Earl, and their Nazi and Japanese puppets. Coexisting with these archvillains is a series of malevolent, woman-hating industrialists and the misogynist shrink Dr. Psycho. Like Priscilla Rich, Psycho is given a personal—indeed, a psychological—motivation for his villainy. He is a short, notably funny-looking guy (drawn by Harry Peter to resemble his own carica-

ture of Nazi culture and propaganda chief Joseph Goebbels), who, years ago, was deserted by his pretty fiancée in favor of a notably handsome man, who also frames Psycho for his crime. The psychologist remains enraged at her choice of masculine beauty over (his) brains and seeks revenge not only on the particular pretty faces that betrayed him, but on all womankind, described by him in contemptuous and degrading terms.

It is interesting that it was William Moulton Marston (PhD, Harvard, 1921), a woman-*loving* shrink, who created this recurring character, through whom he delivers an early and admittedly eccentric version of the feminist critique of Freud. But then Marston's feminism *was* eccentric, marked by a belief in women's essential moral superiority, combined with a demand for the equality of opportunity that would permit physical strength and social power to become feminine attributes alongside that superiority.

In the early days of *Wonder Woman*'s existence, Marston published an article in the *American Scholar* about gender issues and was also interviewed for *Family Circle* magazine, whose consultant he was on matters psychological, about *Wonder Woman* and her real-life counterparts. Few commentators on feminism and, I imagine, absolutely no other creators of comic books found the pages of two such different periodicals open to their views on either feminism or the comics, much less to the relations between them. The interview, moreover, was conducted by a member of Marston's own rather unusual family circle, since Olive Richard, the interviewer, was the pseudonym of his lover, Olive Byrne, the mother of two of his four children, who all lived with Marston, his wife, Elizabeth Holloway Marston, and *their* two children. (It was Byrne whose sartorial signature was the pair of wide Indian bracelets on which Wonder Woman's are modeled.)

In both venues, Marston expressed his belief in women's innate superiority, which he maintained that society needed to recognize if it was to survive. He also discussed the need for fantasy role models, along with actual opportunities for girls and women to develop their

strengths. Rejection of the inferior social role was so natural, he asserted in the *American Scholar* piece, that:

> [n]ot even girls want to be girls, as long as our feminine archetype lacks force, strength, and power. . . . The *obvious remedy* is to create a feminine character with all the strength of *Superman* plus all the allure of a good and beautiful woman. (Marston 1943–44, 42; emphasis added)

This solution might have been obvious to Marston, but the way he implemented it was to strike his fellow psychologist Frederic Wertham—the real Dr. Psycho?—as presenting the precise opposite of an "obvious remedy." And, of course, in the postwar context in which, six years after Marston's death, Wertham was indicting the comics for causing or exacerbating a wide range of social ills, including gender transgressions, it was Wertham who both reflected and helped shape the dominant ideology.

For anyone who knows—not to mention those of us who lived— the history of the 1950s, Marston's *Family Circle* remarks are interesting because of the tangent he takes, veering away from his *American Scholar* position about the connection between fantasy and social reality. All women, he claims in the later article, possess as their birthright the same abilities that Wonder Woman deploys so effectively. They even had access to the same tools, for the ones we see in the comic book, material extensions of her power, are simply visible metaphors for what women are and what they can do. In the interview, Marston expresses confidence in women's ability to govern and, in so doing, achieve lasting peace:

> I tell you, my inquiring friend, there's great hope for the world. Women will win! Give them a little time and the added strengths they'll develop out of this war. . . . In all seriousness, I regard that as the greatest—no, even more—as the only hope for permanent peace. (Richard 1944, 19)

Demonstrating a devastating lack of prescience, moreover, Marston goes on to indicate that he expected women's wartime service and the skills it would give them to constitute the final step toward full equality and more. What World War I began in that direction would be completed and reinforced, for,

> in this worse war, women will develop still greater female power . . . [so that] by the end of the war that traditional description "the weaker sex" will be a joke—it will cease to have any meaning. (Richard 1944, 15)

Here, Marston, who understood so well the power of a single image, his "obvious remedy" for the rejection of female identity, underestimated the postwar backlash itself and the role, within it, of media manipulation. For, as the 1950s closed in and Wonder Woman was demobilized along with her sisters in the military and *their* far more numerous sisters in war production on whom all sorts of occupational doors were closing, an enormous propaganda effort swung into operation. This was an effort aimed at normalizing the American woman's domestic role and its essential adjunct, her traditional gender identity, with its heterosexual underpinnings and consumerist ethic. Bolstering discriminatory institutions, the mass media, advertising, pop psychology and therapeutic practice, along with mainstream religion all presented variations on the same theme of the normal and right way to be a postwar woman. This was the future adumbrated by Diana Prince's crush on Steve Trevor and "the girls'" unremitting shallowness, and I fled without knowing quite what it was I was running away from.

What I was fleeing *to* was precisely Wonder Woman's enchanting physical power. It was the mythic version of a quality I also sought in more realistic fiction for young readers where I found myself identifying with the tomboy characters because, as I indicated in "Looking for Wonder Woman," they challenged traditional female roles. But,

as I did not go on to point out but felt very keenly, most of the fictional tomboys eventually ran up against the wall of postpubertal expectations, learning that they had to sacrifice some part, if not all, of their success on the playing field in order to master the newly important game of heterosexuality. Even Jo March—the most important of tomboy heroines to many of us, because she was explicitly literary, as well as athletic and rebellious—eventually mellowed into mothering all those little men. In this sense, although Diana Prince was vulnerable, Wonder Woman never, never grew up.

The theme of heterosexual romance certainly looms large in the Wonder Woman narrative, but, despite Princess Diana's reasons for choosing to emigrate, we are never allowed to forget that the *real* story, for both Wonder Woman and Diana Prince, is her mission, which, in the early years, means helping to win the war. Still, the superhero manages to occupy two points in a peculiar love triangle, with Diana mooning over Steve, while he is desperately in love with Wonder Woman, even though he occasionally gets entangled in (real and feigned) amours with some slut of a fascist agent. A frequent final-frame thought balloon expresses Diana's amusement, resentment, or even sorrow that Wonder Woman not only gets all the credit for *her* superheroism, but also the devotion of her man.

Of course, this motif simply echoes a successful DC formula. As every child knows, Clark Kent is crazy about his *Daily Planet* colleague Lois Lane, who won't give him the time of day because she is in hot pursuit of Superman. In both cases, the bespectacled alter ego wallows in unrequited passion, despite the patent dramatic irony, the knowledge each shares with the reading audience that it is their true self that the beloved actually loves. Since Superman really *is* an extraterrestrial and Wonder Woman *is* an Amazon, while the secret identities are only disguises, why all the needless suffering? Even accepting the convention that not even Steve or Lois can be admitted to the great secret, why deflect the consequent frustration onto the false issue of the triangle? These questions are especially salient in the case of Wonder Woman where, in her superhero avatar, she does have a

love relationship with Steve, although one that "Amazon law" prevents from being consummated.

Then again, what would consummation possibly mean in the world of 1940s comics? Marriage, of course, but with no reference to what, to use Etta Candy's phrase, you might do with a man once you've got him. The few "normal" heterosexual relationships represented—normal, that is, in that they do not involve gods, magic spells, imprisonment, or mind-altering drugs—do not give the feminist imagination much to work with. There is, to be sure, the case of Elva, the elephant trainer (*Wonder Woman* no. 1, Summer 1942). Japanese spies (Wonder Woman, who knows all human languages, susses them out by detecting their Japanese accents in spoken Burmese!) have been killing the elephants to ruin the circus, which has been raising money for American troops, and Elva's fiancé, Dom Carey, handsome young man on the flying trapeze, is suspected. Once the mystery is solved, the lovers win the avuncular impresario's permission to wed: "You can both keep your jobs! Now that Wonder Woman has caught the elephant killers, my show can go on!" But no similar happy ending is available for Steve Trevor and the superhero. "Wonder Woman—my beautiful angel!" he cries in the last frame, "Don't leave me. Stay with me always." Her answer restates the narrative's basic premise: "Steve darling—I cannot! The Amazon law forbids it. But I shall always be near you—nearest sometimes when you least suspect it!" So why does she get so drippily upset when Steve doesn't pay adequately affectionate attention to Diana Prince?

Although the two circus performers will continue as colleagues, most of the employed women we see in the Wonder Woman story, even in wartime, are unmarried. When the original Diana Prince wants her ID papers back so she can support her family (*Sensation* no. 9, September 1942), she creates a problem for her husband, Dan White, as well as for Wonder Woman. The superhero needs the "Diana Prince" identity to function, whereas Dan "needs" to keep his woman at home. Once his unlikely invention is adopted by the U.S. military, however, its efficacy proved by its becoming the object

of an espionage plot, the little woman doesn't need to work, after all. Let the disguised Wonder Woman be Diana Prince, for *she* is content to stay home as Diana White, happily shackled to the abuser, whose mood presumably lightens once he's been put "in charge of making disintegrator shells" for our side. She coos on his lap while Wonder Woman holds their baby. In the final frame, in her Diana Prince identity, the superhero tells her, "I'm glad to get my position back. But I envy you yours as wife and mother!" This from the person that Dan White, mistaking her for his wife, recently chained to a stove. "What a perfect caveman idea!" she exclaimed at the time. But, as in other episodes, keeping an existing marriage, however abusive, together is all that matters. Changes of male behavior are therefore accomplished as readily as changes of superhero costume—or exchanges of identity.

Marston could hardly have been aware, when he chose the unremarkable name Dan White for the neurotic inventor that, some thirty-seven years after publication of the episode, more than three decades after his own death, an actual Dan White was to make headlines in a case where traditional definitions of masculinity hardened into madness and murder. *That* Dan White, assassin in 1979 of San Francisco mayor George Moscone and gay city councilor Harvey Milk, even eerily resembled the cartoon one from 1941. The latter had carroty red hair, but the way it is styled and, more important, the crazy body language, at once tightly wound up and loosely held, are strikingly similar. (Of course, we can't see a comic book character move, but the documentary film *The Times of Harvey Milk* shows the historical Dan White as what hindsight recognizes as creepily repressed.) In the self-justificatory tape that was recorded after he was taken into police custody, the confession is interspersed with the double murderer's sense of impotence brought on by his inability to provide adequately for his wife and child, a failure he blames on the mayor and the gay leader who'd advised him. I know it's just a bizarre coincidence about the name, but I can't help feeling uneasy when I think of a Dan White, even a drawing bearing that name,

being placed back in the patriarchal saddle through his role in weapons manufacture!

Although Wonder Woman is surprisingly uncritical of men who tyrannize over their own families, there is more to the romance theme than these couples. That "more" turns out to be intimately connected (I was going to say "bound up" but wait for it) with the relationships I characterized earlier as involving "gods, magic spells, imprisonment, and mind-altering drugs." Marston's vision of female power as the great peacemaking force in the world was related to heterosexuality as he understood and embraced it. The "love" that Aphrodite, in these comics, as in the Greek myths, represents as a counterpower to "evil and aggression" and their enactment in war is eros, not agape. It is no slip of the pen that causes the goddess to reply to Ares' boast that "his men" will rule the world by the sword that "her women" will rule men by the power of love. Marston's *Family Circle* interview makes it clear that the love the goddess is talking about is not the chaste sisterly solidarity of Paradise Island (or, for that matter, the Holliday College campus), much less the spiritual force lauded in Christian religious tradition. Rather, it is based in the appeal that women have for men. When he characterized Wonder Woman as not a fantasy, but an allegory and thus, in her way, true to life, he claimed that her military accoutrements served as reflections of a universal feminine power, adding:

> Her magic lasso is merely a symbol of female charm, allure, oomph, attraction—every woman has that power over people of both sexes whom she wishes to influence or control in any way (Richard 1944, 17).

That this universal sex appeal is universally hetero in its fleshly enactment is made explicit in the paragraph that ends with the assertion that women are the world's only hope for perpetual peace. A couple of sentences back, Marston asserts categorically that when women rule (the aftermath of World War II that he confidently anticipated), "there won't be any more [wars] because the girls won't want to

waste time killing men. They'd rather have them alive, it's more fun, from a feminine point of view" (Richard 1944, 19).

Far from the lesbian vibes Frederic Wertham picked up from Wonder Woman, Marston here projects a flirtatious vision of female power based on a kittenish heterosexuality. "The girls" would much rather have sexual fun with men than kill them, so women's loving rule will be based on erotic satisfaction. Combined with the bondage motif that runs through *Wonder Woman*'s early decades, beginning in the "Moulton" period, this version of feminism gives one pause. From Marston's point of view, it appears, someone always has to be on top. Through the millennia that men have held sway, war, with women as part of its "natural spoils," has devastated humanity. Once women have the upper hand, however, peace will reign, because they will rule men through love—men's love for them, which, however, cannot kick in to enthrall them until women *already* have dominion over them.

So the vaunted "independence" that Wonder Woman preaches to the Holliday girls and others is a means to a two-sided end: it assures that women will not be (or permit themselves to be) enslaved, at the same time that it looks forward to a time when men, having made contact with their unacknowledged fears, will surrender to a sexual desire based on subordination to female power in all areas of life. Thus, in *Wonder Woman* no. 7 (Fall 1943), the issue featuring the life vitamin, possession of that tonic means that all the "good people," those "whom Aphrodite chooses," will be around in the fourth millennium. When Hippolyte shows her daughter America's future, Wonder Woman is delighted to learn that in the year 3000 a woman will be president of the United States. "But," the queen warns her, "American women will not rule supreme as we Amazons do. A man might run for President—he might even beat *you* at the polls!" Although Wonder Woman gamely replies, "I'd like to see him do it!" she isn't really delighted with the results, because it transpires that, in the election of 3004, after foiling the evil Dr. Manly's plot to regain power for killer men, it is Diana Prince who wins the office over Steve

Trevor. Back in 1943, on Paradise Island, Wonder Woman laments, "Oh Mother, he *didn't* beat me after all—I almost wish he had—poor Steve." Hippolyte's answer epitomizes Marston's philosophy: "Silly girl—Steve and all men are much happier when their strong aggressive natures are controlled by a wise and loving woman."

Marston's argument plays on Freudian notions about male desire for the mother, an urge (which, as a good early twentieth-century psychologist, he universalized) that was understood as a desire to *be dominated* by the mother, rather than to possess her. By contrast, women's peacemaking propensities are essentialized, in his view, in terms of their sexual subjectivity, rather than their maternal nature. Depending on how you look at it, this is either revolutionary news or off-the-scale eccentricity. Wherever else women are defined as born peacemakers, it is "supposed" to be because women are the mothers of the race, giving and nurturing life, rather than seeking to destroy it. It is decidedly *not* supposed to be because keeping men alive is a more appealing erotic option! This way, though, Marston can have his cake and eat it too. Men's need to be dominated does not have to be balanced by women's need to control, but rather by women's *jouissance*, which can emerge only after male aggressivity is subdued—and then erotically sublimated.

The theme of enslavement is thus played out over and over in the early Wonder Woman stories. Bondage appears in almost every issue—frequently enough that, in combination with scantily clad female bodies and frequent rollings around in combat, it becomes difficult *not* to associate it with a pornographic fetish. Other superheroes get tied up a lot, too, but for Wonder Woman the theme is substantive, political. The motif continued, moreover, and was exacerbated in the increasingly less feminist version of Wonder Woman created after Marston's death in 1947. Slavery, however, was much more important as a metaphor during his lifetime, Wonder Woman's Moulton years.

That villains—whether Nazi or underworld—want to enslave women and frequently have dungeons full of drugged, cooperative female captives by the time we first encounter them is (perhaps) not all that surprising. Wonder Woman does her best to liberate such prison-

ers from mental as well as physical fetters, and ardently combats backsliding motivated by misplaced love. (The metaphor is treated very differently, here, from the readiness of an abuse victim to return to her traditional role in the family.) But, although the foe is the enemy of something called democracy, of which Wonder Woman's America is emblematic, slavery is nonetheless part of the Amazon way of life. Women being reeducated by Wonder Woman's island sisters are, on one level, trained to function as individuals independent of male control, but we observe them doing so within a regime that is not only rigid in its structure, but is headed by an autocrat whose absolute rule is itself subject to the further absolute rule of the goddess Aphrodite.

Indeed, Amazon education is carried out on the same repressive model. When Wonder Woman comes to the elementary school to pick up little Gerta, Baroness Paula's daughter whom she rescued from Nazi captivity (*Wonder Woman* no. 7, Winter 1943), she finds the children (by this time, we know that the Paradise Island Amazons do reproduce by art-as-parthenogenesis) all kneeling at their work table, their hands clasped behind them as if chained, and the teacher refusing to release them for another hour, because they have been "inattentive." This tyranny is not the problem, but Gerta's willful behavior is. (Well, she does throw a piano at the teacher!) When Wonder Woman consults the Magic Sphere, she sees the terrible fate in store for Gerta, who, in twenty years, will head a spy ring made up of her own slaves, one of whom will turn on her mistress and shoot her dead. But in this (perhaps unique) case, the information on the Sphere is not definitive. If Wonder Woman can change Gerta now, she can arrange a more hopeful future for the child. Ultimately, though, it is maternal love that does the trick, for Gerta's feeling for her mother forces her to obey when even Wonder Woman cannot reach her. Wonder Woman deflects the rescued Gerta's thanks: "No dear, your mother saved you. . . . She is the one person you love enough to obey always." She then turns to Paula with further instructions: "Greater danger . . . threatens Gerta—she is growing self-willed and scornful

of authority! You must take her to America with you and teach her love and obedience." To which the free and independent scientist Paula responds, "I obey gladly, Princess."

This is the repeated lesson of nineteenth-century literature for and about children. Your own will is always wrong, anger is always sinful, submission, even to injustice, is always the way to go. From Jane Eyre to Jo March, the reader is led to identify with the angry girl, only to learn that maturing means curbing not only the expressions of righteous wrath, but the feeling itself. It is more surprising to find the same doctrine being propounded by a twentieth-century psychologist, but at least easier to understand as part of Marston's overall view that violence, apparently present in the female child as in the male, but absent from the makeup of the adult woman, must be chained by some kind of love, whether familial or erotic, holding aggressive will in thrall. (Instead of the pleasure principle being at odds with the reality principle, as in Freud's theory, it is represented as doing battle with the murderous death principle. Reality can take care of itself, for the Amazons and their followers love their work, while, once only erotic desire rules, death can be conquered.)

I want to stress that I am not imposing a prefabricated interpretation on Wonder Woman, but rather reading the words and images in the light of the creator's own expressed views. The themes of dominance and bondage are not just a titillating subtext in the Wonder Woman stories, but constitute important plot elements. Yet they coexist with slogans about democracy, occasional plots stressing social justice issues (fair pay for department store salesgirls, in one case, affordable prices for milk, in another), where Wonder Woman is invariably on the right side. And they coexist, as well, with a kind of civic feminism that reflects the same support for social equality.

For the early Wonder Woman, whether she fought Nazis, gangsters, or, more cosmically, the god of war himself, espoused a vision of wartime democratic values, along with a chaste passion for Steve Trevor, that betrayed none of these more complex—and decidedly more adult—currents. However idiosyncratic and sexually charged

Marston's brand of feminism was, its result was a hero who told women—the characters she addressed and all of us readers who were eavesdropping on her speeches—to stand up for and, if necessary, *by* themselves. The difference between Marston as ideologue and his alter ego Moulton (in adventure-comic terms, his secret identity) is the difference between a worldview based on generalizing from individual psychology and one based on observing social forces.

When Marston-as-Moulton translated the social into narrative terms, he located Greek gods, classical heroes, and modern villains under the rubric of a crude but usually de-eroticized sexism. That is, women are not primarily sex objects to those *macho* figures, they are objects, period. The goal was to enslave, rather than to ravish, and women were more often described by the bad guys as being not smart or not strong, without reference to the afterthought that they were also desirable.

In contrast to the erotic charge that motivated Marston's feminism, *Wonder Woman*'s feminism is sanitized, even hygienic. The love theme is a prepubertal girl's vision of romance, the kind you played with paper dolls. The early Wonder Woman and I are both too old for Barbie and Ken comparisons where, even stripped to their bare plastic basics, these two have bodies that are primarily designed as a frame for a costume and its associated lifestyle. Paper dolls are like that, though, flat—literally, rather than figuratively two-dimensional. And, although they lived to wear clothes and one sent them out on dates—even I, the anti-Trevor, did that with my paper dolls—there were usually no boy dolls, so one couldn't follow them on these excursions, and the narratives necessarily involved the girls' relations with their wardrobes and one another.

It occurs to me that my dollhouse also figures in memories of the stories I based on the ones I read in "real" books as well as comic books. For Christmas when I was six, my older sister's boyfriend built me an exquisite four-room dollhouse with a roof that came off to permit access to the rooms. Other girls had mass-produced ones with open backs, but I gloried in the masterpiece of eighteen-year-old Dan

Post's artisanship, with its deep-eaved green roof. The Post family had recently redecorated their house, so the walls of my dollhouse were papered with their leftover scraps, different, of course, for each room, and my floors, like theirs, had wall-to-wall carpeting. For some reason, the little dolls I was given along with this house were babies, instead of a family, and this troubled me not at all. The babies had fabulous adventures, not the least impeded by their age or the diapers that were their only costume, until I made a tiny superhero's cape that they shared among them.

Once—it must have been the sixth successive day of rain—my brother, age eleven, condescended to join my dollhouse game. "How come these babies live alone?" he demanded, and then, before I could explain, as literal-minded in my way as he was in his, that this was just the way it was, he answered his own question: "They must be Live-Aloners." He proceeded to devise a plot where the Nefarious Grownups (I'm sure we didn't know the term "social workers") tried to break up the Live-Aloners' household and haul them off to an orphanage. I don't think my brother ever played dollhouse with me again, but, as long as I continued to do so—for years—I felt duty bound, every once in a while (my duty being to narrative, I guess) to include a game where the self-sufficient—not to say superheroic—babies fought off constituted authority. Surely, we didn't learn *that* from the comics. As far as we knew, the state and its organs, police and military, depended on the unquestioning loyalty of superheroes, and Wonder Woman represented the (adult-headed) family as the righteous extension of constituted authority. The Live-Aloners, need I say, were a tribe of girls.

Which brings me back to the kind of feminism that *Wonder Woman* officially espoused, a feminism that had both a personal and a civic dimension. Wonder Woman's speeches, as well as her sterling example, are about how women can do anything men can do, whether that "anything" was the work of brain or brawn. A female superhero may be "stronger than Hercules," as well as being as beautiful as Aphrodite and as wise as Athena, but those who are not, we

were told, could still rely on their common sense, their ingenuity, and their solidarity. The point she reiterates, although it is constantly belied by her own combination of superabilities and magic, is that she merely leads the way for all women, since all have within them (within us!) the requisite power to conquer the forces that would restrict female life and possibility.

On what I have called the civic level, there is no hint in *Wonder Woman* of the matriarchy Marston envisaged for twenty-first-century—indeed, for postwar—American society, although by 3000 things do seem to have changed. If Paradise Island is a society that allows no males, America is represented as the land of gender equality, actual and potential. The early *Wonder Woman* reinforces this approach by reference to real-life superheroes. In its first couple of issues, the new comic enterprise was endorsed by a panoply of athletic stars of both sexes, who enthusiastically signed on to the Wonder Woman idea. One of them, the tennis champion Alice Marble, stands out in an advisory role, "presenting" the stories of women from history or current events who have earned the label of hero.

Each issue of the early *Wonder Woman* thus included a cartoon biography—considerably shorter than any single adventure episode—of a woman identified as a real-life hero. These women include healers Elizabeth Blackwell, Clara Barton, Florence Nightingale, and Edith Cavell, suffragist Susan B. Anthony, antislavery advocate Sojourner Truth, and organizers Lillian Wald and Juliette Gordon Low. The only "ringer" in the crowd is Madame Chiang Kai-shek, also mentioned in William Marston's *Family Circle* interview as evidence that women can accomplish anything they set out to do and that World War II will provide American women with opportunities for self-development equal to those the Sino-Japanese War offered Madame Chiang. Emphasis on wartime service as offering greater scope to women runs though the biographies, where it does not have to face directly the contradictions inherent when the pacifist Marston had to talk fast to explain how women's engagement in the current war would lay the foundation for enduring world peace!

The biographies are drawn in what I might call the "documentary" cartoon style found in texts where cartoons are used to convey nonfiction information. The colors are also different from those in the rest of the comic book, muddier and less exciting to the eye. Since these biographies are short, they focus on one aspect of the subject's life, typically introducing it with an account of an early struggle against sexist attitudes or customs and often featuring, as well, a moment of public recognition—receiving a medal from the president, say. Aside from Madame Chiang, where everything from her selection as a hero on becomes questionable (not to say downright embarrassing) in the glare of hindsight, there are few memorable moments in these biographies. One shows Juliette Low's black, presumably enslaved mammy commenting, in stereotyped dialect, of course, on the Northern soldiers singing "When This Cruel War Is Over," when, she says, it was they who made the war. (As if!) Another shows the monument to Nurse Cavell, quoting her famous observation that patriotism is not enough, we must also have love. This sentiment is used to explain, in the final frame, what is wrong with the creed embodied by the current enemy, the Nazis: they do not love humanity. (Elsewhere in *Wonder Woman*, too, fascism is defined as an ideology "of hate," without much reference to the racism at the heart of that hate.)

As a psychologist who had presumably read his Jung, as well as the mythography of at least the Greco-Roman tradition, Marston knew that certain archetypes had great cultural power. When he reached into the mythographic pool in order to further the cause of women, he did not hesitate to stand the archetypes on their heads, appropriating their power while deploying it to tell a story diametrically opposed to the source narrative. But neither Marston nor any of the comics professionals involved in the early *Wonder Woman* seems to have had any idea of how to translate the same excitement into the stories of historical women achievers. The biographies fall flat, not only as representations of heroes, but even as stories. The genre they evoke is the illustrated Bible story, and any kid knows those aren't

real comics! These vignettes were probably most readers' only expo-
sure to women's history, so the fact that they exist at all is laudable,
although, for that very reason, it would have been a good idea to
make them attractive enough to *be* read. It is notable that the real-life
heroes are almost all women who achieved more with their brains
than their bodies, and that the bodies are represented, in the vast ma-
jority of cases, as being lumpish enough to cut them off from the
world of heterosexual give and take.

Not so for Wonder Woman. Her body is admirable, in part, be-
cause she worked hard at developing her natural athletic and specifi-
cally combative skills to the highest level. In the origins story, we
actually see Princess Diana going into training for the anonymous
competition whose victor will be sent from Paradise Island to join the
war effort. Motivated by her love for Steve, she works (and works
out) feverishly to perfect what we are given to understand are already
superior skills. But, even so motivated, hers is not a walkaway victory.
The other young Amazons who want the honor of fighting for Ameri-
can ideals (defined also as feminist, remember), those whose hormones
are presumably under better control, are by no means easy to beat.

Once she is the only Amazon regularly on the scene, however,
Wonder Woman cannot rest on her laurels, because each adventure
demands her superb strength, flexibility, and coordination. More to
the point, given the genre, each adventure *displays* those qualities,
along with a theatrical élan in their deployment that endows a Won-
der Woman rescue, escape, or knockout with the panache of a circus
performance. (For the youthful comic book audience, of course, to
make a circus of something is to elevate it, not to reduce it.) The use
of magical equipment enhances the body's power, and may be recog-
nized in performance terms as a kind of special effect.

In Wonder Woman's case, limitations on her physical prowess are
built into the equipment, as a moral-political warning, rather than a
design function. The term *Achilles' heel* that is conventionally ap-
plied to such limitations denotes the single weakness in the hero's
physical makeup. Achilles' mother held him by the heel while dipping

him into the Styx, which would make him invulnerable, so that portion of him didn't get wet and thus was left unprotected. (I guess we're not supposed to notice that this is a pretty dumb way to dip a baby into a river.) Superman, being a native of Krypton, is desperately weakened by exposure to kryptonite, the flaw subsisting in his genetic code, as Achilles' flaw is in his tendon. Wonder Woman's weakness, by contrast, is built into her bracelets. If a man is ever allowed to chain or weld them together, thus literalizing the injustice of male supremacy, she loses all super strength. This is because the bracelets were bestowed on the Amazons to remind them not to succumb to the seductive power of the opposite sex.

Wonder Woman never does submit consciously, so this contradiction built into her otherwise wondrous, bullet-deflecting bracelets serves more as a booby trap than as a reminder. She never lets her guard down and, until the bracelets *are* connected, she possesses super strength, so it is only when she is drugged or blackmailed (protecting Steve or Etta, say) that she "allows" it to happen. Although the ostensible reminder is about sexual and affective vulnerability, the penalty is exacted as a result of forces unrelated to such vulnerability. It is as if institutions and practices designed to protect women's sexual integrity were used against rape victims, whose sexuality has been violated against their will. Come to think of it, that's exactly what did traditionally happen in rape cases.

In the dialectics of Wonder Woman's magical matériel, the bracelets serve another function. They look like restraining devices, because they are. As long as Wonder Woman wears them and they *haven't* been chained together by some guy, her physical powers, enormous though they be, are directed by her wisdom, and she is under control, emotionally. When the bracelets come off altogether, as occurs in a number of episodes over the years, she reverts to savagery. Not only is her anger unleashed to its full destructive potential, but she expresses it irrationally, unable to employ strategic thinking or even a sense of proportion in the decisions she makes. In this sense, too, the bracelets serve as a reminder—an ever-present emblem of the fact

that fighting "evil and aggression" effectively must engage the mind, as well as the body. It is significant that this reminder, too, is external to the superhero's own attributes, although it regulates her using them in the best possible way.

Equipment aside, the body is at the center, Wonder Woman's body, and that body is coded as being as close to perfection as the female body can get—which, in the simplified discourse of the comics, boils down to "perfect," period. There are two orders of physical perfection, of course, especially for women: that of beauty and that of muscular power. And, because the ideal, the definition of perfection in each area changed, so, in the 1940s and 1950s, did the representation of Wonder Woman's body, both as object of admiration or desire and as subject of its own prowess. Changes in the representation of the body were also paralleled (and sometimes actually signaled) by changes in costume.

Thus, as the ideal objectified body in beauty contests, on the silver screen, and in calendar art became thinner and bustier, so too did Wonder Woman's body. The upper part of her costume was always strapless, suggesting that she had wherewith to hold it up. (Beyond this mere suggestion, some months she was drawn with a definite cleavage—although that might not happen the next month.) But it was not until the late 1950s, in the period of "decline" delineated in my "Chronicles" chapter, that the wings of the golden eagle on her bodice appeared to have been transformed into a pair of cups for increasingly hypertrophied breasts. Similarly, the star-spangled bottom of Wonder Woman's uniform changed, after the first few issues, from a skirt—which had been progressively attenuating—to something more closely resembling shorts or a bathing suit, also with a general tendency to become briefer over time. The effect of the alterations in the costume was consistently to reveal more and more of the body, while emphasizing it as a thing of beauty.

As for muscles, we know Wonder Woman has them because we see her using them. Ours is a narrative as opposed to a visual knowledge, however. She is proficient in gymnastics, in the ancient Greek

sense of the term, but she does not go to the gym in any more familiar contemporary way. Throughout the Moulton period and into the decline, she accomplished her remarkable feats without any apparent definition in her biceps or her thighs. Her calf muscles, highlighted by the red boots, are developed only to—but not beyond—the point required for "nice legs" in the pinup sense. In some of the 1940s covers by Harry G. Peter (how I wish I were making up that name!) she has a sturdy chest above the decorative bosom, but other work from this period by the same artist shows her without that development. At no time did muscularity overshadow or even threaten the conventional notion of beauty. Wonder Woman could be strong and we might see her deploying that strength, but, in contrast to Superman's superb Kryptonian chest or the pectoral, abdominal, and lateral results of Batman's hours of weight training, the audience was not permitted to see what *made* her strong. The conventions showed that she could be a fighter and still be ideally attractive, but she could not be ideally attractive and have anything remotely resembling a fighter's body.

Four

Chronicles
Generations of Super-Girls

AS SOMEONE WHO WAS BORN in the same year as Wonder Woman and who therefore began serious comic reading around 1946 or 1947, I remember the female superhero most clearly in her distinctly diminished postwar avatar. The years when I was becoming an increasingly strong reader (and, in a groping seven- or eight-year-old way, an increasingly strong feminist, as well) were the very years of Wonder Woman's decline from an inconsistent but unquestionably liberatory icon into something quite different. In the *Wonder Woman* of the late '40s and the '50s, not only was the wartime democratic crusade replaced by a far less global mission, but the theme of heterosexual romance was insistently foregrounded. Our hero possessed the same superpowers as before, but they were increasingly oriented toward law enforcement, rather than saving the world, and Steve Trevor increasingly blocked a view that was increasingly not there to see, anyway.

It turns out that it was not, in fact, the end of the war and the loss of its idealistic focus that precipitated the crisis, but the death not long afterward of William Moulton Marston. His utopian-feminist dream died with him, but Wonder Woman, or a character bearing that name and outline, albeit increasingly untrue to her creator's vision, was delivered into a prolonged if spurious afterlife at the hands of male artists and scriptwriters who shared no part of Marston's

larger vision. So Wonder Woman began to resemble her imitators, rather than the other way around.

And imitators there were, both before and after Marston's death. Wonder Woman may have been the first female to invade superhero territory, but she didn't remain alone for very long. I say "may" in deference to those who would make a case for several short-lived female heroes whose adventures actually predated those of Wonder Woman. Trina Robbins, for instance (1996, 3), identifies *Thrilling Comics'* Peggy Allen, a policewoman who assumed the role of the Woman in Red, as "the first costumed superheroine," since she initially appeared in 1940. Robbins calls the costumed role a "secret identity," whereas, for what might be called the mainstream of superheroes, including Wonder Woman, the secret identity is the one dressed in mufti, who holds a regular job (reporter, secretary, nurse) or at least has a documented nonheroic life. (Bruce Wayne is, after all, a society playboy when he's not being Batman.) The secret identity is the one who seems to observe the adventures that right wrongs, rather than being part of them. But it is not this reversal—an effect of Robbins's careless taxonomy, rather than anything the comic itself does—that removes the Woman in Red and several other early characters from serious contention as the first female superhero. Rather, if ironically, it is their obscurity that keeps the red-hooded cop, along with a host of male heroes' girlfriends and sidekicks, obscure. Because they never had comic books of their own, never attracted a significant following, they made no real impact on comic book history, and had no opportunity to capture the popular imagination in which Wonder Woman has been established for more than six decades.

Like Charles Moulton's successors at DC Comics, the creators of the later comic series featuring superpowered women drew narrative tension from the incongruity between gender identity and heroic powers, although with no reference to either Amazonian myth or to feminist ideas. There might be a special pleasure in defeating a villain who permitted himself a sexist sneer at his "girl" antagonist, but that

was as far as it went. It is in this sense that the other female super-heroes from the period of Wonder Woman's decline and eventual fall—a period dating roughly from the death of William Marston to some point a few years beyond the appearance of the new-old Won-der Woman on the cover of the first regular issue of *Ms.* in July of 1972—had so much in common with the denatured Amazon of those years. They were similarly diluted representations. From this long pe-riod of decline in the popularity, sales, and influence of comic books, as well as in the creative contributions of female superheroes, I will be concentrating on three, Mary Marvel, Supergirl, and Invisible Girl, with a side glance at the original Black Cat, as well as consider-ing the ever-weakening contemporary representations of Wonder Woman.

From 1940 to 1954, Fawcett, which, under several corporate names including Marvel, brought us such Golden Age superheroes as the Human Torch, the Vision, Captain America, and Submariner, also published a series of comics devoted to a Superman clone called Captain Marvel. The series ceased publishing as a result of DC's suc-cessful lawsuit for copyright infringement, since dressing a caped, fly-ing hero in red instead of blue constituted insufficient protection against the claim of intellectual-property theft. (You could say that, after the court decision, Fawcett lost its Marvels. It's the sort of thing Marvel writer Otto Binder *did* say in his scripts all the time.) In the 1960s, the Marvel Comics that eventually triggered a renaissance of the genre, bringing us the Fantastic Four, the Avengers, Spider-Man, and the Incredible Hulk, among others, revived some of the names and narrative details of some of their older characters that were not under indictment and also resurrected the Captain Marvel name for a black female superhero, at one time a member of the Avengers.

In the original, suppressed Marvel family, there was, first and foremost, Billy Batson, copyboy for a great metropolitan daily (they didn't really make it all that hard for DC's lawyers, did they?), who changed into Captain Marvel by calling the name of the wizard

Shazam. "Shazam" brings together the first letters and salient attributes of Solomon (wisdom), Hercules (strength), Atlas (stamina), Zeus (power), Achilles (courage), and Mercury (speed). Billy's adopted brother, the crippled newsboy Freddie Freeman, became both hale and heroic as Captain Marvel Junior, whose status at one remove from the empowering force was signaled by his having to cry out "Captain Marvel" to change identities. In the Plato's cave of the Marvel series, Junior was thus the shadow of a shadow.

The other member of the clan (for of Hoppy the Marvel Bunny I will not speak!) was Mary Batson, Billy's slip of a separated-at-birth and recently rediscovered twin sister, who became Mary Marvel by once more invoking "Shazam," although for her the letters stood for the names of goddesses and other classical figures and the associated virtues include more stereotypically feminine ones. (The S signified Selena, for Grace, and then we had Hippolyta for strength, Ariadne for skill, Zephyrus for fleetness, Aurora for beauty, and Minerva for wisdom.) Mary joined the character family as of *Captain Marvel Adventures* no. 18, December 1942 (Robbins 1996, 206). In addition to the usual bad-guy suspects, Mary had an archenemy of her own sex, the redoubtable Georgia Sivana (Binder and his puns at work), daughter of Captain Marvel's mad-scientist enemy, Dr. Sivana.

One of the interesting differences between the Marvels and other superheroes is that, in their "real life" secret identities, they are represented as being around twelve years old, on the cusp of puberty. When he is transformed into Captain Marvel, Billy Batson also acquires adult features—looking in fact rather too much like Superman, which was the problem in court, after all. But the transformed Mary remains a preadolescent whose superhero costume is basically a simple red dress with the Shazam lightning logo on its modestly cut bodice, plus, of course, a cape and boots. There is nothing sexually suggestive about the outfit, nor about the actual garments—casual play clothes—that the company marketed to readers under the Mary Marvel label.

Because Mary was eternally twelve, her stories included no love stuff to make me uneasy about her possibly dwindling, in Congreve's memorable phrase, into a wife. As far as I was concerned, her principal value was that, like me, she had a heroic older brother who, like mine, simultaneously took care of her and enabled her to assume an identity undaunted by gender barriers. I now know that he wasn't, in fact, her elder, but I clearly wanted to identify with that aspect of her situation, so, if there was any mention of the twinship in the issues I read, it went right past me. I may have been encouraged in this attitude by the fact that, although I knew *identical* twins (my mother was one), I had encountered no boy-girl twins other than the insufferable Bobbseys, who, unlike the superheroes or the characters in the more literary fiction I was about to discover, lived their two-dimensional lives entirely on the page. Anyway, in each of the boy-girl Bobbsey pairs, the girls were a double bore: Nan had no adventures of her own and Flossie, the "Fat Fairy," was an embarrassment from her name on out. Aside from all that, it may be that if the Batsons' being twins didn't come up often, I was taken in not only by my own needs but by the simple fact that, once in costume and ready to fly, Captain Marvel really is a lot bigger than Mary. The thing is, apart from her personal importance for me as a sister who could follow in her brother's footsteps—or flight path—there simply wasn't a lot *to* Mary Marvel. She could fly, was strong and agile, she fought crime; none of that is what you'd normally call ho-hum, but, in this frame of reference, at least, it was not sufficiently special, either.

As for her physical prowess, because her superidentity came about entirely through magic, no effort had to be expended in the acquisition or perfection of her superskills. She got to be strong by the same means that she got to fly, and nothing a girl does at the gym can help her *there*. The result is that Mary Batson is a slender, attractive kid and Mary Marvel, too, is less robust than the early Wonder Woman who, even at the time when she was drawn without too much in the way of muscular development, always appeared the literal picture of health. And, just as Mary Marvel owed her identity to

the true superhero, her brother, so she died with him, not because she was a demonstrable rip-off of DC's Wonder Woman—a case that would have been much harder to prove—but because she was essentially an appendage of Captain Marvel, who *was* a rip-off. He was the linchpin of the enterprise, literally holding the family together and, even if the court did not ban all members of the clan, the Fawcett workshop was apparently unable to conceptualize Mary's flying solo. Were any further evidence required, this would prove that she's no clone of Wonder Woman!

Yet, during her lifetime, Mary's adventures were featured in four different venues (her brother's book and her own, as well as *Marvel Family* and *Wow Comics*), appearing in a total of 172 individual comic books before the suppression of the Marvels (Robbins 1996, 68). This makes her the most widely circulated female superhero after Wonder Woman, although that figure and the attenuated life span make it abundantly clear why Wonder Woman gets so much of the attention, from criticism to kitsch, while all her early contemporaries seem to congregate under the dismissive rubric "et al." Even in her distant second place, however, Mary did make some contributions to comic book tradition.

For one thing, she helped normalize the superhero's alternative identity. Whereas Superman is an extraterrestrial and Wonder Woman, although human, is a member of a privileged race, the Batsons' "real" identity is a couple of regular American kids, whose original and subsequent transformations occur through the intervention of magic. Batman was also human, needless to say, but he was set apart from his readers by his age, his fabulous wealth, his uncompromising mission, and the combination of training and equipment that enable his superheroics. (For a glimpse of how exaggerated the workout and the electronics have become in later years, see Vachss 1995 and the review of it that I co-authored, Bishop and Robinson 1996.)

In the hands of a feminist—whether of Marston's stripe or some other—Mary Batson's very ordinariness (she wasn't even the one cho-

sen for superdistinction by the ancient wizard in the subway tunnel) could have become an ideological virtue. For example, sometime in the 1940s an institutional advertisement from *Wonder Woman*'s publisher appeared in major magazines for adults (Daniels 2000, 122). It shows a middle-class family in their living room, Mom engaged in her mending, Dad in his newspaper, and their little girl lying on the floor next to the floppy-eared dog, dreaming of a future influenced by the historical role models featured in *Wonder Woman Comics*. The copy says that "with all due modesty, [our parent company] is proud to have illustrated . . . in words and pictures . . . why these famous women are revered, why youngsters would do well to emulate these idols." Moreover, the publisher claims that not only their own titles, but "all the popular comic books as well, have contributed to presenting just a little more than pure wholesome entertainment." Daniels does not give a date for this ad, but it has to have been prepared before January 29, 1944, when Josette Frank of the Child Study Association, who is listed as a member of the Editorial Advisory Board, resigned from that body, charging that "intentionally or otherwise, the [*Wonder Woman*] strip is full of significant sex antagonism and perversions" and adding that she "would consider an out-and-out striptease less unwholesome than this kind of symbolism" (qtd. in Daniels 2000, 72). Ironies and contradictions aside, Wonder Woman's creators did present those vignettes of admirable woman meant to set girls, like Jane in the ad, "impassionately [*sic*] dreaming" of what they might become when they grow up. The fact that Mary Batson is just like you, and that you, therefore, whether or not touched by a wizard, might become some kind of role model, too, is in no way indicated in the Marvel Family saga and is certainly not part of what was being sold to the girls who were her particular fans.

That there were such fans is suggested by another, rather more questionable contribution made by Mary Marvel, this one in the area of association marketing. In the comics, the Mary Marvel Club was formed as a result of a 1945 adventure in which Mary Batson and her

friends, barred from an all-boys' club, create their own single-sex organization, rout some thieves in the course of setting up their clubhouse, and then turn the tables on the now-eager boys by keeping their group all female (Robbins 1996, 59, 68). Thereafter, girl readers of the comics in the Marvel Family constellation were invited to send in a dime to join that club, receiving, in addition to the affiliation, a pin and a membership card that said nothing about the club's goals and values.

By contrast, when Wonder Woman solicited readers' ten-cent contributions it was for the March of Dimes (the President's Birthday Ball), and they, in return, got not only the satisfaction of giving to a cause that Wonder Woman and her mother had espoused, but also an "autographed" picture of the superhero (Robbins 1996, 9 and Daniels 2000, 45 both reproduce the 1943 ad). The four-color lithograph was described as being "suitable for framing," the comics' euphemism of choice for the more candid "unframed." And, although there eventually was a Wonder Woman club on Paradise Island and a card entitling the holder to its secrets, this was an artifact of the decline. A more typical document from Wonder Woman's wartime period, "signed" by her, certifies charter membership in the Junior Justice Society and reminds the holder that he or she is pledged

> to help keep our country united in the face of enemy attempts to make us think we Americans are all different, because we are rich or poor; employers or workers; native or foreign-born; Gentile or Jew; Protestant or Catholic. And makes the further pledge to defeat this Axis propaganda, seeking to get us to fight among ourselves, so we cannot successfully fight our enemies—knowing full well that we are all AMERICANS and believe in DEMOCRACY and are resolved to do everything possible to help win the war! (reproduced in Daniels 2000, 57)

I don't know if it cost money to belong to this organization, but it seems unlikely in the light of its espousal of the most high-minded reasons for contributing to the war effort. But the Mary Marvel

Club, once its origin was forgotten, not only had nothing to do with making the world safe for DEMOCRACY, but also claimed no continuous mission of bolstering girls' self-esteem. It seems to have been a way of picking up a few extra bucks while conducting a census of the most loyal readers. I would not discount the few bucks, either, since, again in contrast with Wonder Woman, which, in the early years, licensed very few products bearing the superhero's image or endorsement (Daniels 2000, 69), Mary Marvel Enterprises, as I remarked earlier, went so far as to sell clothing that would enable a girl consumer to dress like Mary in her nonsuperhero moments. In this context, the Mary Marvel Club was out to save Dime-ocracy.

Another inadvertent contribution of Fawcett's Marvel series to the comic book form may have been the blurring of genres, something that was to have a significant impact on the definition of female heroes and the narratives in which they appeared. The original DC Comics now seem rather pristine in adherence to a particular narrative genre. For Superman, it is science fiction, for Batman, techno-drama, for Wonder Woman, modernized epic. Not only did the classical gods and heroes recur, but "Great Hera!" was also our favorite Amazon's favorite oath. Contrary to Daniels's claim, "Suffering Sappho!" was not uttered all that often, until *Wonder Woman* rediscovered feminism in the 1970s (103). By contrast, the original *Captain Marvel* offers a mishmash of science fiction and confused mythopoeic elements—the latter drawn, as the names contributing to "Shazam" suggest, from the Bible, from Roman as well as Greek versions of the classics, and from those same sources' demigods and human heroes. And those are only the names evoked when *Billy* Batson says, "Shazam!" When Mary utters the magic word, we get not only Selena, Aurora, and Minerva, the moon and dawn deities, as well as the goddess of wisdom under her Roman name, but Hippolyta and Ariadne in the same sentence. Two distinct moments in the not very nice sex life of Theseus? Not to mention Zephyrus, the wind, who is invoked by his masculine name, but is represented as a goddess! (Robbins 1995, 56). This last bit of gender-bending doesn't

seem to me to mean much, though, and matters even less, because ultimately Mary Marvel was not as much about myth as marketing. And, contrary to Robbins's complacent, undocumented assertion that "thousands of twelve-year–old girls fantasized about becoming Mary Marvel," neither those putative thousands nor anyone else seems to have mourned (or even much noticed) her court-ordered disappearance from view (104). The Marvel genre-bending did have far-reaching effects, however. As time went on, *Wonder Woman* absorbed some of those heterogeneous (or at least heterogeneric) influences, bringing extraterrestrials, as well as a wider mix of gods and heroes, into stories that shied increasingly away from offering challenges to prevailing gender restrictions.

Having almost incidentally destroyed Mary Marvel in 1954, DC proceeded, in the late 1950s, to reimagine her as Supergirl. As the Superman family expanded, the hero acquired a pretty blonde cousin, also a refugee from the planet Krypton, who was quite strong and could fly and all, but although she was dubbed the Girl of Steel, as far as I know, she never grew into a woman of that same resistant metal. (Indeed, as we shall see, Supergirl, young and nubile as ever, is once again going—flying—strong at the end of the millennium.)

Whereas Superman's emergency interplanetary migration occurred when he was an infant, his cousin, daughter of his father Jor-el's brother Zor-el (can you prove that these are *not* authentic Kryptonian names?), wasn't fired off in *her* rocket ship until she was a teenager. It seems that when ecodisaster threatened their planet, Zor-el had time to encase his city, Argo, in a radiation-proof shield, allowing it to become a free-wheeling, temporarily protected planetoid during all the years that Clark Kent was growing to (super-) manhood in his terrestrial exile. He is already the adult Superman when his cousin lands, which suggests that the survivors in Zor-el's city (the Argo-nauts) were continuing to reproduce up there, since, when their literal bubble bursts, or at least ceases to be secure, the new Kryptonian exile is years younger than her cousin. I dwell on this discrepancy because the Batson kids become different ages when they

assume their superhero identities, with Mary remaining a girl while her brother is a man, and also because, between Wonder Woman and the Invisible Woman, there is such a plethora of heroic girls—or, usually, Girls. This may have reflected a campaign to get young female readers aboard, but no similar effort was aimed at boys, who were encouraged not only to identify with other boys in the stories they read, but with superheroic *men*, whereas, in keeping with '50s ideology, girls would always be Girls, and Amazons aside, there was barely such a thing as a superheroic woman.

Upon first meeting his cousin, Superman gasps in astonishment, "Great Scott, a young girl, unharmed! But . . . But that means you're *invulnerable*, like me" (*Action Comics* no. 252, May 1959). Gender counts as much as genetics, though, so he is clearly reassured when she gets all weepy, upon receiving a standing ovation at the UN: "Physically, she's the mightiest female of all time! But at heart, she's still as gentle and sweet and is [*sic*] quick to tears—as any ordinary girl!" (*Action Comics* no. 284, 1962). He has trained her for the heroic role and, in her first superhero adventure, she has stepped onto the world stage, winning the gratitude of JFK, who urges her to work for world peace, as well as fighting crime, and Jackie, who "looks gorgeous." Yet, her adventures lack epic scope, and, because of that, their civic side also falls flat. The result is the absence of both Wonder Woman's heroic feminism, based on her antagonistic relation to patriarchy, and her civic feminism, based on notions of equal participation in society. Instead of the president and the UN making Supergirl seem bigger, her "stay as sweet as you are" girlishness seems to diminish them, to reduce them to her gender-dictated scale.

Or maybe what's really bothering me in the Supergirl story is her heroic steed, Comet the Superhorse. What's wrong with a heroic steed, you ask? After all, they're a staple of adventure narratives in all genres, and there's no reason that someone who not only can fly but also has access to rockets and airplanes shouldn't also. . . . Well, yes, of course, and there's no a priori reason why the horse should not possess a few superpowers of his own. Comet would not even be the

first flying horse in myth, after all. But that her horse should be desperately, if secretly, in love with Supergirl and we readers be privy to his ruminations about the relationship—I think that moves us too rapidly from epic to comedy to farce. (This horsie is a veritable Diana Prince– or Clark Kent–style loser, romance-wise.) The motif does, however, give some "legs"—equine legs, to be sure—to a 1998 episode (make that thirty-six years, seven presidents, and a whole lot of comic books and feminism later), in which Supergirl has a love affair with a long-haired (silver-maned?) individual named Comet, whom experimental surgery has provided with the limbs of a horse!

Or maybe it's the shadow of the long 1950s, stretching from approximately 1947 to 1963, that informs both Supergirl's limitations and my response to them. Unlike Charles Moulton, the comics creators of the '50s were not consciously providing a vision of gender. Rather, they were uncritically echoing social norms and attitudes it never occurred to them to challenge, so that Mrs. Kennedy's compliment, "You are as resourceful as you are lovely, Supergirl!" carried little conviction. As a '50s girl, she doesn't *have* to be resourceful, as long as she is lovely. Of course, the movers and shakers in the comics industry, along with their employees on the creative side, were themselves moved and shaken by the steady decline of the genre that took place in this period.

The decline was not unrelated to the larger forces that defined the '50s, but comics faced more immediate hurdles, as well. One of them was the ethos reflected in, if not indeed shaped by, Wertham's *Seduction of the Innocent* (1953), which constructed the comic books themselves as a "problem" and helped establish a restrictive code for its resolution. Then there was the growing popularity of television, occupying the leisure and affecting the mentality and consumer choices of the comic book audience. Come to think of it, though, both the Wertham-hysteria and the rise of TV were intimately connected with the Cold War and thus, in terms rather more intellectually sustainable than that period's trademark guilt by association, to '50s gender roles and stereotypes.

If Mary Marvel was the second most widely represented female superhero, after Wonder Woman, the second longest-lived one, once again a distant second, was Black Cat, who, between 1941 and 1965, went through the nine proverbial feline lives in her own books, as well as in *Pocket Comics, Speed Comics, Black Cat Western, Black Cat Mystery,* and a newspaper strip. In addition to longevity, she shared with Wonder Woman the dubious honor of being an object of attack by Frederic Wertham, who was as frightened of a slinky, sophisticated movie star on a motorcycle as he was of a nononsense (well, let's face it, lots of fantasy nonsense) Amazon and her crew of undergraduate adjuncts. As the Western title on Black Cat's list indicates, she also switched narrative modes, not only moving, as Wonder Woman did, from fighting Axis spies to fighting local and international crime, but also from these essentially contemporary and urban assignments to cleaning up the lawless frontier. In each of these venues and for each of these missions, Black Cat—or rather her alter ego, Hollywood actress Linda Turner—is described as having become bored with the ultrasophisticated life her professional success has won her and therefore turning to whatever form of ass-kicking she currently espoused. The origins issue, however, tells a different, more idealistic story (*Pocket Comics* no. 1, 1941). Here, having long suspected her German director (another vaudeville-Deutsch who says things like "Himmel! Vot iss") of being a Nazi spy, Linda observes his superstitious hatred of the dusky feline who is her pet and decides to "become" a menacing cat while tracking down such malefactors. Linda is a jujitsu expert and, as a former stunt girl, is also good at astonishing leaps and climbs, but she possesses no powers that go beyond normal human capacities, physical or mental. And she has no connections to other, older traditions about gods who intervene in human life and the humans who have been touched by them.

Nevertheless, her identity must remain a secret, and Black Cat, like so many superheroes, has someone who is in love with her and

obsessed with learning who she is, without realizing or even suspecting that his confidante Linda is the real object of his desire. The innovation here—and it is one—resides in the fact that the secret identity, this time, is also highly desirable by conventional standards. The difference between Linda and Black Cat is not their beauty, but rather the fact that the masked, scantily clad superhero is committed to a mission and superbly gifted at carrying it out. (I'm not discounting the exotic allure, but he apparently chooses Black Cat because she's a tough and able crime fighter.)

Even Steve Trevor's preference for Wonder Woman over Diana Prince breaks some new ground, in that the superhero, in addition to being superbly beautiful, is someone he admires for nontraditional qualities, like enormous strength and martial skill. He's also aware of her brainpower, which not only solves some of the problems they confront, but also served to save his life, at the beginning of their acquaintance. In the hero's secret identity, Diana Prince is still allowed to use her brains—she doesn't need the decrypting manual because the words are all in her head, and she can take dictation faster than most of us can move a pen—but this just earns her a pat on the head from Trevor. So we know it's the physical prowess he admires, as well as the fact that Wonder Woman doesn't sport eyeglasses and a frumpy hairstyle. Diana's spectacles and Clark Kent's serve the same purpose in different ways, although in neither case does that purpose have anything to do with enabling them to see better. Whereas hers help her look dowdy so Steve doesn't fall in love with her, Clark's make him look less manly than his alter ago and inferentially nobody loves a weak man. Wonder Woman and Diana never compete on grounds of "womanliness," because the superhero's very existence challenges that category.

This fundamental fact remained as Wonder Woman began its decline after Moulton's death. Even Daniels observes "how large matrimony loomed as an issue for Wonder Woman in the 1950s" (102). It is he who points out that what replaced the "Wonder Women of History" feature was, of all things, a column titled "Marriage a la Mode,"

which debuted precisely in 1950, documenting wedding customs around the world! I may have run away from Diana Prince and her dreams around then, but I admit that "Marriage a la Mode" wasn't compelling enough to make it onto my radar screen, and I'm sure I still read the odd issue of *Wonder Woman* at that time.

Interestingly, it was in the period of decline that Wonder Woman learned to fly (*Wonder Woman* no. 105, April 1959). The issue in which she learns also relates a new origins story, which, most significantly, eliminates the Amazonian background and hence the nonreproductive creation of the Amazons themselves and of the queen's daughter. This new conception (as it were) of Wonder Woman makes her the child of human parents whose powers are individual gifts of the gods. That is, they are neither communal nor earned by her own efforts (108). The ability to fly, characterized as "gliding on the air currents," is one of those gifts. Since the other innovation of this period is the introduction of Wonder Woman at earlier life stages— Wonder Girl, a teenager, and the even younger Wonder Tot—we can see her practicing the art as she grew up. "I ready, Mommy," babbles the Tot, whose mastery of English has apparently lagged behind her aerodynamic skills. (As Dorothy Parker notably remarked in her review of *The House at Pooh Corner*, "Tonstant Weader fwowed up.")

The creation of Wonder Girl, who, with her ponytail and a modest costume, was the focus of entire episodes and a couple of covers, coincided with the erasure of the Amazon background, which in itself indicates a soft-pedaling of feminist themes. It was also connected to a growing emphasis on heterosexual romance. For Wonder Girl is entirely a Girl, a standard teenager of the (mediated) 1950s, which means that she always has one foot in the world of boyfriends and dating. Indeed, she is popular within and outside her own species (we are, after all, still in a world where her main squeeze is Mer-Boy!). Not only is male rivalry over the much sought after Wonder Girl a salient theme in this period, but the motif also starts to appear in the adventures of the adult Wonder Woman. Daniels's comments about this development are superbly point-missing. First of all, he claims

that the Wonder Girl episodes won a great deal of approval "from either the audience or the editor" (meaning *someone* must have liked it?), and then, speaking of the new competition for Wonder Woman's favors, says that "having to fend off so many pretenders to the throne is doubtless one of the drawbacks of being a princess, though the stories depicted it as a wonderful world of fun" (109). Well, no. That's not the usual drawback of being an *Amazon* princess, the heritage that has been traded and not necessarily with her consent, for being queen of the prom—the world for a "world of fun" being, perhaps, the worst bargain since Esau sold his birthright for that mess of pottage. What was being sold off, in this case, wasn't only a more interesting story, but the imaginative scope of American girls.

The steepest decline came later, however, marked by a transformation of Wonder Woman's body type and costume, in issue no. 178, September-October 1968. From then until 1971, the magazine was titled *The New Wonder Woman* and, from May-June 1970 on through 1972, the covers stated that each issue "starred" Diana Prince as that icon, once again weakening the Amazonian connection. In the first such "new" issue, an irreproachably long-legged, skinny version of the superhero, her hair teased and straightened, is shown still holding the bucket of black paint she has used to slap big Xs across both of her old avatars, Wonder Woman clad in her stylized Old Glory suit, magic lasso at the waist, bracelets and tiara in place and, next to her, Diana Prince in her tiresome uniform and glasses. "Forget the old," that cover orders, while the next one proclaims that, "It's goodbye to the past." As an ad in a previous issue trumpeted, "Yes, a really big change is coming to Wonder Woman!"

Up to that point, Wonder Woman's uniform had always been based on the American flag with a superimposed golden eagle. The skirt may have metamorphosed into shorter and shorter pants, but the patriotic motif remained. Now, in 1968, when Yippie Abbie Hoffman was getting busted for wearing a U.S. flag shirt as an antiwar protest, Wonder Woman divested herself of the colors and appeared one month in full mod gear, the next in a Grecian tunic. She

did not don the flag costume again until the reintroduction of feminist themes in 1973, a date that also happens to coincide with the "Vietnamization" of the war in Southeast Asia and the consequent defusing of the flag garment as an object of controversy.

It is in this period that Wonder Woman's body was slimmed down to suit her hip (but decidedly not hippie) clothing. In the process, she, who was always both young and ageless, starts looking younger still. She continues to be shown wielding all sorts of weapons, striking blows from midair, leaping over flames, and all the rest of it, but, whether clad in ancient or mod garments, she is, from the standpoint of physique and apparent capacity, no Amazon. Significantly, the covers from this period show her battling more female foes than ever. In the last issue before she is stripped of her traditional habit (July-August 1968), she squares off against Supergirl. Then, in rapid succession, the "new" Wonder Woman has to fight masked, full-breasted figures in no. 181 (March-April 1969), the disfigured "Cyber" in no. 188 (May-June 1970), a medieval knight whose armor is shaped to accommodate her bosom in no. 192 (January-February 1971), the knife-wielding "Beauty Hater" in no. 200 (May-June 1972), and the Catwoman herself, Batman's enemy, in no. 201 (July-August 1972). In these encounters, which have a lot more in common with catfights than with epic struggles, sexual jealousy or simple envy of Wonder Woman's good looks rate high as motivating forces and the old notion that female enemies can and should be redeemed has disappeared.

Wonder Woman, like the traditional DC line generally, never went in much for irony. (In fact, it occurs to me that, along with other forms of wit and humor, from slapstick to wordplay, irony tended to be the province of DC *villains*, whereas heroes never went much further than informing a defeated bad guy that the joke was now on *him*.) The tendency in *Wonder Woman* was to replace ethical and political ambiguity with an almost compulsively reiterated theme about deceptive appearances obscuring an unambiguous truth. Thus, there were narratives about false claimants to the Wonder Woman identity,

about multiple identical "Wonder Women," about some distorting or deforming magic that alters the Amazon's appearance, about mirrors only one of which is reflecting the truth. As with identity, so with ideology. There may be inconsistencies, but basically, over the years, Wonder Woman has been either feminist or not. The period I have been describing as the nadir was, of course, decidedly "not." The so-called new superhero, out of uniform and battling mostly female enemies while conforming to the sexy '60s ideal, embodies a cultural definition of femininity that helps to demonstrate why the (also) so-called Sexual Revolution struck so many women as also not—or at least not yet—a *women's* revolution.

But change was in the air. Steinem credits *Ms.* with what she does not hesitate to call Wonder Woman's "rebirth" as a feminist. With some difficulty, *Ms.* persuaded DC to allow an article by Joanne Edgar appearing in the magazine's maiden issue to be illustrated with images from the Golden Age and also obtained permission to adapt the 1940s version of Wonder Woman for the magazine's inaugural cover. With this representation, according to Steinem, "Wonder Woman appeared on newsstands again in all her glory, striding through city streets like a colossus, stopping planes and bombs with one hand and rescuing buildings with another" (1995, 16–17).[1] Anyway, she is striding well *above* the street, so one might at first perceive or eventually remember her as flying (which, after all, she had been doing for some years, although readers of Steinem's vintage or mine, our memories fixed on the earlier period, remain convinced that Wonder Woman could not fly without her invisible plane). Under the *Ms.* logo is the banner "Wonder Woman for President," its white lettering on a red ground mirroring the billboard on a housetop below that reads, in red letters on white, "Peace and Justice in '72." She holds a rescued group of (inferentially Asian) buildings in the shadow of her magic lasso, while, apparently next to the all-American town that cries out for peace and justice, is a scene of planes, bombs, parachutes, and tanks assailing what looks like a Vietnamese village.

Wonder Woman is not, in fact, able to stop the attack, but she presents a clear alternative to this representation of war and injustice.

But that was *Ms.*'s Wonder Woman, not DC's. Steinem attributes to the direct impact of her magazine a subsequent turnaround in the real thing that I would connect, instead, to the phenomenon that made *Ms.* successful, the rise of feminism as a mass movement. Responding to evidence (including, certainly that of *Ms.* itself) that there was a wide audience for an empowered female hero, DC hired its first woman editor for the series and restored Wonder Woman's original costume, paraphernalia, and abilities. Early in 1973, a tough-talking male writer for the comics phoned Steinem to say, "Okay, she's got her Amazon power back. She talks to the Amazons on Paradise Island. She even has a Black Amazon sister named Nubia. Now will you leave me alone?" (Steinem, 16).

Cultural history is a bit more complex than this self-congratulatory anecdote would suggest. The changes must have felt enormous, particularly as seen from inside the DC bastion, but it took a while for them to go beyond the superficial to the superheroic. Wrapping herself once more in the Stars and Stripes—an outfit that could be coded as feminist in the '70s only insofar as it retained associations with the old kick-ass Amazon and her original mission—did not make for an abrupt shift in the visual message. A number of covers, for instance, still showed Wonder Woman confronting a female adversary. On the first cover of the "feminist" epoch, no. 204, January-February 1973, an enthusiastic grandstand of Amazons watches as a big-breasted, wasp-waisted figure wearing full armor and a visor stands poised to stab a downed Wonder Woman, broken sword at her side. The cover of no. 106, June-July 1973, shows Wonder Woman and Nubia, virtually identical except for skin color and the latter's jungle-print outfit, shackled to one another at wrist and ankle and dueling with swords. And, in the very next issue, Wonder Woman and her mother are foregrounded gagged and bound back to back, while a jury of warrior women calls for a verdict of death.

The sadomasochistic appeal to a consumer turned on by the sight of scantily clad, nubile women tied or chained up and assaulting one another's sexy bodies is still present. Only the few words on the cover suggest that the narratives within carry a message about a different kind of empowerment. Announcing the rebirth, no. 204 is titled *New Adventures of the Original Wonder Woman*; the copy makes reference to the superhero's second life, and states that this issue introduces Nubia. It also indicates that the mistake that may kill Wonder Woman arises because Queen Hippolyte has another, hitherto unacknowledged daughter (who is presumably the victorious warrior wearing the armor and ready to strike). Similarly, the small type beneath the scene where the two sisters are dueling tells us it is our old buddy Mars, the god of war, who has forced—indeed, "brainwashed"—them into this combat to the death. And, while it is not clear why the assembled women warriors (are they Amazons or anti-Amazons?) are calling for the death penalty, the words on the cover of that issue do ask, "Can the mighty Amazon rescue her mother and herself from the JURY OF DEATH?" in a way that makes it clear that the eventual answer will have to be "yes."

In short, the new narratives do emphasize female power and female solidarity, but they continue, for some time, to be illustrated so as to send the old, sexist message to anyone experiencing comic books chiefly on the level of the visual. The transitional representation tailed off by 1974, however, and hereafter, with a few notable exceptions, the enemy tended to be male or monstrous (or both), unless it was mechanical, and the suspense resided in whether Wonder Woman would be able to overcome the hostile force in time to save herself or the entire city of New York (no. 205, March-April 1973) or, no Cold Warrior she, Moscow (no. 214, October-November 1974).

As I have indicated, the (perhaps premature) feminist rebirth itself was signaled on the January 1973 cover by the words "New Adventures of the Original" over the *Wonder Woman* title. Then, as of no. 212, June-July 1974, and until 1976, the epithet "Super-Heroine

Number One" was highlighted somewhere on each cover. Coinciding with the reiteration of this assertion, another, unintentionally ironic, way of underlining Wonder Woman's recently valorized heroism focused on her equality with male superheroes. To this end, many issues featured other DC heroes—including Superman, Batman, the Flash, the Red Tornado, and the Phantom Stranger—"presenting" Wonder Woman's adventure or actually "co-starring" in it. It is as if, by pulling a (sometimes literally drawn) curtain aside to show us Wonder Woman's latest exploits, the male and decidedly masculinist heroes were conferring legitimacy on her, accepting her into their macho pantheon.

At the same time and more literally, these DC superherees were testing Wonder Woman's suitability for rejoining the Justice League of America. On the cover of *Wonder Woman* no. 212 (June-July 1974), she is not only invited but begged to come back. Superman, his cape streaming in the wind, the other Leaguers behind him, cries in two colors, "Please Wonder Woman! You *must* come back! The Justice League needs you!" Hand on forehead, magic lasso gleaming at her waist, she replies, "No, Superman! I cannot!" But eventually, of course, she does, also taking part, in this period and beyond, in animated TV versions of the League.

Another manifestation of feminist consciousness was the introduction of some more explicit gender politics into *Wonder Woman* episodes. On the cover of no. 263, January 1980, a grinning villain riding an apparently flying (though not winged) horse has lassoed the Amazon up from the street in front of the U.S. Capitol, declaring, "Even with all her powers, Wonder Woman is no match for the Gaucho—a real man!" A few months later (no. 268, July 1980), the cover announced that this is the end—also the beginning—for Wonder Woman as she discards her glowing headband and lasso before the UN building and states, "I've had my fill of the evils of Man's World. As of now, I quit!" (This is a particularly well-known image, because it was reproduced on licensed products in the 1990s and after.) She does indeed return to Paradise for a few issues, although we learn in

no. 270 (August 1980) that she's "abandoned Man's World forever—but still she cannot find peace." (Small wonder, since her island seems about to be engulfed by a tidal wave!)

During this period of retirement, we are also privy to the origins story with another "new twist," when Queen Hippolyte offers her daughter *the* costume and she replies, "I'm sorry mother—but I don't want it!" (no. 271, September 1980). The next month, however, she's back in the USA, clad in that very costume and ready to face what the cover calls her "greatest foes." She's shown posed before a montage of Washington, DC, buildings and the American flag, with a huge golden eagle perched on her bracelet. Meanwhile, purportedly by popular demand, a new female superhero, the Huntress, is the focus of her own *Wonder Woman* supplement. I have characterized these episodes as explicitly feminist, but the principal manifestations of such politics are caricatures of overt machismo like the Gaucho's combined with rejection of male violence and male "evil." Although this may be read as an extension of Moulton's original vision, it may also be a reflection of the women's movement as represented by writers and artists who knew nothing about feminism except what they could glean from media distortions, and who proceeded to perpetuate those distortions in yet another medium. So feminism, in these comics, often means just being antimale, and the new *Wonder Woman* lacks ideology beyond that definition, paying almost no attention to any concrete issue raised by women's liberation beyond the crudest battle of the sexes polarities. Although the Holliday girls are still on the scene, their solidarity is not foregrounded as it was in the past, and there is rather less of that supposedly lesbian-tinged mutual rescuing than there was in the '50s, when Frederic Wertham got so exercised over it.

Speaking of exercise, the visual representation of the reborn and newly feminist Wonder Woman changed several times in the period from 1973 to the beginning of the Amazon's postmodern phase (which may be traced to issue no. 1 of the "Fantastic New Series," February 1987, after the *Crisis* issues that brought an end to DC

Comics as we knew them). All of the modifications in the superhero's appearance made her more beautiful and more overtly sexy by the prevailing standards of the day, but, although her powers were restored and triumphant, her physique did not seem to reflect this greater strength. It was her breasts that grew, not her muscles. Or so it appears, until one takes a look at the four-part miniseries *The Legend of Wonder Woman,* issued in the "interregnum" between May and August of 1986 and drawn by Trina Robbins, an artist with a background in the feminist comix of the 1980s and an abiding interest in women's role(s) in the superhero universe. In this series, Robbins employs a deliberately neoprimitive style, restoring the look, the features, even the hairdo of the original 1940s Wonder Woman, simplifying the lines with which the superhero is drawn, and generally clearing the background of the multiple figures, events, and actions that had come to characterize *Wonder Woman* from the mid-'70s on. If anything, the cleaner lines and flatter surface of Robbins's pastiche reveals that Wonder Woman had, in fact, become more visibly powerful—not, to be sure, by developing bulging muscles, but in accordance with dominant fashion, by acquiring the hard body, buns of steel, and other attributes of the devotee of aerobics classes, Nautilus machines, and NordicTrack. Her look, in short, is right in style for the '80s, and, next to her, Robbins's revived '40s icon, although too slender to appear flabby, seems positively *soft.*

Some of the changes in drawing style that become apparent when contrasting Robbins's conscious antiquarianism with *Wonder Woman* of the late '70s and the '80s probably came about through the influence of Marvel Comics. In the Marvel universe, even the names of the individuals who constitute the Fantastic Four, the Avengers, and the X-Men reflect the publishing group's chief contribution to the genre—an irony that is at once self-aware and self-reflexive. The ways in which the Marvel characters acquired their superpowers, the very conception of those powers as mutations, the frequent ambivalence some of them exhibit toward the powers themselves, the continual quarrels among teammates, and their further

ambivalence toward their mission as superheroes all reflect this fundamental irony. Marvel's stylistic departures, complicating the basic drawn line by making it seem to move more rapidly, and varying the familiar color scheme of the traditional comic book, may also be tinged with self-conscious irony. The style reflects what popular art became—indeed, had to become—once the primitive comic mode had been appropriated by and adapted into the art style that is called "Pop" but whose exemplars started selling for big bucks and being exhibited in major museums. By making viewers aware of comic art *as* an art style, and by treating that style with the combination of irony and respect it granted to other mass-produced commodities from Campbell's soup cans to the multiply reproduced photos of Marilyn Monroe, Pop Art forced self-consciousness onto the comics. They lost their innocence, and the evolving Marvel style and tone was one of the results.

What may be called the new Marvel attitude begins with the creation in 1961 of *The Fantastic Four*, with mutations, internecine insults, ambivalence, and irony all over the text, but drawn in the traditional adventure or detective comics mode. The first major change in artistic style did not occur until well into the 1960s, after the success of Pop Art. I do not insist on this "post-Pop ergo propter Pop" argument, but it seems to me suggestive, not only of a seismic shift in visual approach, but of the growing importance of the visual domain that was later to mark the "Revelation" phase of comic book history in general and the female superhero experience in particular.

Marvel's first female superhero, Invisible Girl, preceded the moment of Wonder Woman's feminist renewal by more than a decade. Invisible Girl was subsequently—and significantly—to become Invisible Woman who, as wife, mother, and superhero, remains one of the Fantastic Four. Along with the other mutants in that group, she was "transformed by an accident in outer space into something much more than human" and has "vowed to use . . . [her] awesome power to help mankind chart the unknown" (no. 357, October 1991). And, as is the case with the other Fantastics, her particular superpower is

an extension of her salient premutation qualities. Sue Storm was a distinctly—almost pathologically—shy and retiring girl. Her invisibility, along with some additional powers, enabled her to help "chart the unknown" on behalf of "mankind," and, in the process, vanquish technologically and cybernetically sophisticated villains, who often possessed convoluted motives of their own. These included but were by no means limited to the alien Skrulls and the human Dr. Doom. Her role and powers increased with time and become most interesting in the period from 1988 on. Throughout, Sue's visible dimension, when not in action, includes no signs of exceptional bodily powers, although, like the latter-day Wonder Woman, she evidently frequents a reputable health club.

The accident that gave the Fantastic Four their superpowers was an artifact of the Cold War mentality. Pilot Ben Grimm initially refuses to fly the rocket ship to the stars, because there has not yet been enough research on the effects of cosmic rays. "They might kill us all out in space!" he insists to the brilliant scientist Reed Richards, his former college roommate (no. 1, November 1961). But Sue Storm, Reed's fiancée, insists on the political necessity of an immediate liftoff. "Ben, we've *got* to take that chance! Unless we want the Communists to beat us," adding, "I—I never thought that *you* would be a coward!" As will happen throughout Ben's subsequent career as the Thing, it is the challenge to his manliness that goads him to accept the assignment, and the four are off. There *are* four of them because, although only Reed and Ben are required for the mission itself, Sue comes along, explaining to Richards, "I'm your fiancée! Where you go, I go." To which Johnny Storm appends, "and I'm taggin' along with Sis, so it's settled!"

In a reprise of the origins story (no. 11, February 1963), it is Reed who explains, "We've got to reach the stars before the Reds do!" while Sue chimes in, "Oh, Reed, if only the government had listened to you in time—heeded your warning!" In this version, she tells the reluctant Ben that she and her kid brother Johnny are planning to ride the starship so that Reed will see that at least *they* are not afraid!

It is worth noting that the U.S. moon landing—I mean, forget about the stars!—was nearly eight years in the future. Even more interesting from a political perspective, once the Four were launched as a superheroic team, the first issues contained very few references to the Cold War. The space race is mentioned a couple of times, a Russian villain addresses his simian sidekick as "Comrade Ape," a suspicious device is said to bear "Communist insignia," and Khrushchev himself is caricatured a couple of times yelling at his subordinates or the whole UN in a fashion reminiscent of wartime's comic book Nazis. But, at their worst, the Soviets are never represented as being or even being in league with the real enemy, which threatens the entire planet, with no concern for national borders or identities. As in representations of World War II, the fight is nominally for "democracy," which is constructed as being synonymous with capitalism, but is not the focus of narrative or ideology, since the battle for world domination is being waged on an entirely different plane.

At any rate, Sue's presence on the flight that exposed all those aboard to the cosmic rays was as an appendage of her boyfriend. In the revisionist 1963 version, she also serves an ideological function, as she and Johnny, a callow teenager who perpetually gets on the Thing's nerves, stand in for the proverbial "women and children" that traditional heroes are pledged to defend. But the cosmic rays are an equal-opportunity mutator, so they get endowed with superpowers, too. With an irony that I assume is intentional, Ben, the only space traveler to express his reservations, is the most damaged, and, for many years, the only one of the Four whose mutated, if superpowered identity, his horrible Thing-ness, cannot be switched on and off at will. Meanwhile, open-minded scientist Reed Richards, the Four's leader, becomes Mr. Fantastic, endowed with amazing flexibility, as well as strength; hot-headed young Johnny becomes the Human Torch, and Sue becomes Invisible Girl. "Together," announces Reed, "we have more power than humans have ever possessed!" But it is the ever-truculent Ben who gets to shout out the

implications: "You don't have to make a speech, big shot! We understand! We've got to *use* that power to help mankind, right?"

Although Sue's nonsuperhero role is as an adjunct to Reed, only rarely do we see the shyness that was her defining trait before the accident. One such case, though, is the government's testimonial dinner in their honor, which three of the Four are extremely reluctant to attend. Speaking last, Sue, who went on the starship voyage to show her fearless trust in her beloved, whimpers, "Oh, Reed, I—I'm *afraid* to go! I'm not used to meeting all those important people! I'm liable to get so flustered that before I know it, I might vanish in front of their eyes! If that ever happened, I'd simply die of embarrassment!" (no. 7, October 1962).

Commenting on a series of frames (*Fantastic Four* Kingsize Special no. 4, November 1966) in which, successively, Sue Storm serves coffee, jokes about the clothing bills she's run up, attends a fashion show, and faints dead away, Robbins observes:

> Unlike the insecurities and self-doubts that afflicted male heroes, and which encouraged the reader's identification and evoked admiration when the heroes overcame them, Sue Storm's . . . flaws were almost a caricature of Victorian notions of the feminine, an invisible woman who faints when she tries to exert herself (1996, 114).

It does not seem to occur to her that, with Stan Lee's characteristic Marvel irony already operating, the caricature may be intentional.

Yet it must be admitted that, in the early issues, Sue assumes a number of stereotyped feminine roles. It is she, for instance, who designs the group's uniforms. When the Thing, with typical self-reflexivity about the comics themselves, fulminates, "*Bah!!* Costumes—tights—that's kid stuff! Who needs 'em?" she is quick on the uptake: "*We* do, if we're in the business of crime fighting for real! If we're a team, we should look like a team!" Even more revealing is her reply when Reed, trying on his suit, praises the design: "Say! This

isn't half bad, Sue! You ever think of working for Dior?" While adjusting the Thing's mask, she answers, "I've got enough to do acting as nursemaid to you three!" (no. 3, March 1962).

In the same vein, Sue is in a "chi-chi beauty parlor on Fifth Avenue" when she spots the flaming "4" signal in the sky. Having waited months for an appointment with the exclusive Monsieur Pierre, she is as upset as the coiffeur himself that she has to rush off before he can create her new hairdo. There is a certain wit, as well as girlishness, to her thoughts as she dashes away and transforms at the same time: "Better turn invisible! I can't run thru the streets with curlers in my hair!" (no. 15, June 1963). More disturbing, because apparently devoid of saving irony, is the moment when Reed finishes his special report for NASA on rocket fuel and goes looking for Sue to type it up. She hastily erases the undersea view-screen on which she has been seeking the Sub-Mariner, the other male in her life, and, once Reed says he wishes that Namor *would* surface again, so she could finally make up her mind, the next caption reads, "And then, after giving Sue the report to type . . ." while the illustration shows him reflecting sadly on his beloved's ambivalence: "Strange how nobody is ever really master of his own fate!" (no. 14, May 1963). Strange, too (if you ask me), how someone whose fate is in another person's hands thinks nothing of placing those hands on a keyboard to serve him and his work!

Much of this comes to a head in issue no. 11 (February 1963), in the same feature, "A Visit with the Fantastic Four," that retold the origins story. Reed finishes his narration of the accident and the consequent mutations by saying, "We've come a long way since those early days—and had many almost unbelievable adventures!" His complacency about this history is shattered, however, by Sue's retort: "But they were *your* adventures—the three of you—much more than mine!" It seems that readers have been sending Sue unpleasant letters, charging that she doesn't contribute enough to the team effort and that the others would be better off without her. "She's not exaggerating," says Reed, when he's read some of them. He shouts, "Well—it's

time to set the record straight—here and now!" It's Ben, temporarily redeemed from Thing-ness, who, for a change, utters the calming note: "Take it easy, pal! The kids didn't mean any harm—they just don't understand!"

Setting the record straight has two interestingly contradictory parts. On the one hand, says Reed, gesturing toward a handy bust of Abraham Lincoln, the Great Emancipator famously said his mother was "the most important person in the world to him," although she did not, as Ben adds sarcastically, "*do* enough" in the chronicle of his deeds. Once invoked, her role as nurturer of Abe and hence of his accomplishments is presumably self-evident enough that it needs no further elaboration, so they move on to the other half of the argument: Sue *does* take part in the comics' action dimension. A couple of examples are cited, her brave leap into the middle of their battle with the Skrulls and her rescuing them all from Dr. Doom's airless prison. Only two dramatic events occur in this Special Bonus Feature. First of all, Ben gets so angry as he admonishes Sue's detractors ("If you readers wanna see women fightin' all the time, then go see lady wrestlers!") that he turns back into the Thing. And the Torch sounds an alarm bell summoning the others away from this discussion to a surprise birthday party the three males have prepared for Sue. ("You remembered!") As she cuts the inscribed cake Johnny has "rigged up" for her, she says, "I'm so choked up I don't know what to say." The Thing comments that it's the first time he's ever heard a female make such a statement, while Reed wishes "Many happy returns . . . to our *favorite* partner!" Once again, stereotype and innovation work together.

In the concluding frame, the editors explain that this episode without a real story—at least, not an adventure story—was produced in response to letters and queries from readers. "From time to time in future issues," they continue, "we shall attempt to pictorially comment on other letters from you—our valued fans!" Whether it really was readers' letters or their own bad conscience, something convinced the creators that it was worthwhile to explain Sue's apparent

failure to pull her superheroic weight. The editors and their characters make it clear that they plan to keep Invisible Girl in the series and that she's just fine the way she is. I wonder, myself, if it occurred to any readers to propose giving her an equal part in the action sequences, rather than removing her from the tetrad. Or to any writers to attempt such a move. It certainly doesn't look that way! After all, Sue herself expresses the official position before becoming invisible and hitching onto the evil Mr. Miracle's truck: "One invisible girl can sometimes accomplish more than a battalion!" (no. 3, March 1962).

Note

1. Every time I read this sentence, it catches me off guard, and I think I've finally figured out why. A colossus is a statue. It does not—it cannot—*stride*. (Unless, as in myths and comics, a divinity brings it to life.) The Colossus of Rhodes (another Wonder, one of the Seven of the Ancient World, in fact) *bestrode* the harbor, that is, it was so big it had one foot on either side of the entrance to the port, and boats sailed in through the statue's legs. So when Shakespeare says, "he doth bestride the narrow earth like a Colossus," that's what he means. What brought on this attack of pedantry, needless to say, is Steinem's appropriation of feminist history.

Five

Revelation
Post-al Superheroes

> The modest goal of the present book is to present a different paradigm for recognizing the "third movement" of superhero comic books and to avoid at all costs the temptation to refer to this movement as "postmodern," "deconstructionist," or something equally tedious.
>
> —Geoff Klock, *How to Read Superhero Comics and Why*, 2–3

I copy this epigraph and want to sniff like a Nancy Mitford nanny, "Very *silly*, dear!" But to do that would be to miss Klock's joke, which I assume is intentional. His whole study is steeped in postmodern jargon, quoting abundantly from postmodern sources, and, in its multifocal eclecticism (citing the left from A to Z—Althusser to Žižek, anyway—and the right as bulkily embodied in Harold Bloom). In short, the dude has written a postmodern critical study of a phenomenon to which he applies only an ordinal label, on the grounds that calling it postmodern would be "tedious." He's got to be kidding—doesn't he?

For my purposes, it's important to give the thing a name (and, name-wise, the Thing has already been taken), because making one's way through the deliberate narrative multiplicity of the new-style comics requires some lucidity. Naming is a move to lucidity—especially if, adopting a principle from another region of contemporary pop culture, one is committed to keepin' it real. If I can establish the

usefulness of postmodernism as a category for looking at the female superhero, it may be of some help in understanding whether and how post*feminism* enters the picture (or drawing). Besides, "third movement," for me is either what starts halfway through a symphony or what happens less than halfway through a day of stomach flu. These specialized uses (terms of art?) aside, a "movement" to me is a social force, and the feminist movement is currently experiencing a third *wave* with close ties to developments on the mass-culture scene.[1] So it's important to know whether the female superhero, after a long incarceration as a girl, should now be identified as a Grrrl. Or if she's better understood as a Woman.

As with any massive aesthetic change—particularly one so sweeping as to embrace both style and substance—the shift to postmodernism in the comics could probably be traced through small increments, issue by issue, through examples from the late 1970s and into the 1980s. You could choose any of the books in the Marvel line for your essential text or contrast the early-'80s Savage She-Hulk with the Sensational one who combusted onto the scene in 1989. Such a painstaking (and arguably asinine) chore is rendered unnecessary, however, by the existence of a twelve-part series, interestingly enough, out of DC, not Marvel, that encapsulates the moment and the shift. This remarkable document, published between 1985 and 1986, is *Crisis on Infinite Earths*. In superhero cosmology, *Crisis* occupies the same conceptual space as an event in chaos theory would in the other cosmos—at least, chaos theory as filtered through comic book science.

Ironically for the inaugural event of postmodernism and for something I am rhetorically comparing with chaos theory, *Crisis* represented itself as a way of restoring clarity and continuity to a DC narrative line that had been telling its tales, like a color-press Sheherazade, for half a century. Over time, the narrative discontinuities and contradictions had become overwhelming, the comic book audience was no longer turning over every few years, and the new audience for the genre manifested a greater interest in its history (Daniels

2000, 165). What those responsible did not say directly is that the new readers were also some years older than the traditional comic book audience, not only because they stuck around longer, but because the genre was now addressed to them. As Klock puts it, "*Crisis on Infinite Earths* was not designed to simply change the DC universe, but to retroactively restructure it around a new organizing principle, specifically, the 'adult ethos'. . . . the very significant demographic shift that made the target audience of the comic book companies eighteen- to twenty-four-year-old college-educated males" (2002, 20–21; if you think it's easy to spilt two infinitives in one sentence, *you* try it!).

I question whether the eighteen- to twenty-four-year-olds are the sole intended audience, although it is clear that they constitute one segment of it. The age cohorts below that one, boys in middle school and high school, also read the comics. And, whether Klock notices it or not, certain post-*Crisis* lines have a strong readership among adolescent girls. If it is not quite the case that, in Klock's words, comic books "were now expected to tell stories for adults using the building blocks of children's literature" (2002, 21), they certainly took on more adult themes, particularly in regard to sexuality, always central when female superheroes are in the (in this case literal) picture.

In *The Vagina Monologues*, one anecdote about the onset of menstruation has a woman tell of the comic book collection she kept at her mother's apartment. When she got her first period, her mother told her, "You mustn't lift your box of comics" (Ensler 2000, 39). This story would have been inconceivable in my comics-reading days, not because we didn't face inane prohibitions associated with menarche, far from it, but because, especially for those likely to be college bound, comic books were no longer part of our lives by that point. In one sense, this was because traditional comics offered no way for the fantasies they nurtured to mature. That's why all the female superheroes except for Wonder Woman were called girls, after all, even though they tended to be older than their readers. And the comics about teenage life that were specifically addressed to girls—*Katy*

Keene, Archie and its spin-offs, and the entire genre of "romance" comics—were meant for readers for whom the worlds of high school, dating, and falling in love were still in the future.

Another dimension of the comics addressed to an older audience is the "Dark Side" concept (actually, a pseudoconcept) prevalent in the new generation of adventure series that has also penetrated the Marvel and DC lines, including those that feature female super-heroes. At its most sophisticated, the Dark Side may be equated with something like Ortega y Gasset's "tragic sense of life." At its most shallow, it is closer to the scary stories told around the campfire to render bedtime hideous. The Dark Side recognizes the permanent presence of an (almost, but never quite) invincible evil force at the center of the universe—a force that is absolutely Other and that nonetheless can manipulate and be reflected in humankind, even, at times, in the heroes whose mission it is to combat it.

The addition of this darker, more adult element is manifested on both the literary and visual levels, where it has engendered a series of conventions that turn all struggles into cosmic ones, so that adventure comics appear increasingly close to illustrated science fiction. At least, they do this in the sections that show us the adventure itself, while also focusing a more varied narrative and artistic rendering on the heroes' lives and personalities between battles.

What the adolescent and older readers bring to the comic book experience, in addition to an interest in adult themes within the adventure context and (perhaps) some greater exposure to nonillustrated science fiction and fantasy literature, is a set of skills peculiarly adapted to successful negotiation of postmodern style. (In deference to the cyberroots of these formative experiences, I should perhaps call them "skill sets.") I suspect that most readers of contemporary "adult ethos" comic books have spent time in cyberspace before they begin reading adventure comic books and that they—especially the male majority—have played fast-paced, multilevel video games and may have some experience with hypertext, as well. Offscreen, they may also have been involved in—even become addicted to—role-playing

fantasy games like "Dungeons and Dragons." All of which gives them an edge in reading these neo–comic books that I (for instance) lack. I suspect I still do better with *Finnegan's Wake,* but that's neither here nor there (although the thing about the text of *Finnegan's Wake* is precisely that it is both here *and* there).

At any rate, *Crisis on Infinite Earths* was geared to opening the way to adult themes by erasing from each series' history not only the inconsistencies, but also an accumulation of dead ends, as well as the characters or motifs specifically designed to appeal to children. The result, whether intended or not, was the opposite of simplification, establishing a set of parallel realities that are or may be the source of "authentic" narrative. This impelled DC along the complex path already marked out by Marvel and eventually pushed Marvel to further extremes along that path. The impact may be seen in the evolution of She-Hulk and Invisible Woman and the female Avengers, as well as in the post-1986 Wonder Woman and in those female superheroes who appeared for the first time in the 1990s and after.

Marvel's She-Hulk bridges the space—conceptual, narrative, and visual—between the feminist and the postmodern (which may also be the postfeminist) worlds. In 1980, Marvel spun She-Hulk off of *the* Hulk (the Incredible one), with an origins story faintly reminiscent of the creation of Eve from Adam's rib. Dr. Bruce Banner, aka the Hulk, comes to consult his attorney cousin, Jennifer Walters, about the police problems his mutated identity has created for him. While they are together, she is murderously attacked by gangsters involved in another of her cases and Banner breaks into a neighboring doctor's office to give her a transfusion from his own blood. Naturally (as comic book nature goes), his mutation is passed on and the same sort of rage that cues Banner's transformations turns her into the Savage She-Hulk. In a subsequent and longer-lived series inaugurated in May of 1989, the She-Hulk, now characterized as Sensational, has not only calmed down considerably, but—and it's not clear which element is cause, here, and which effect—she has come to terms with her

99

mutation. Although she can switch at will from "being" Jen Walters to "being" the She-Hulk, she spends most of her time—including her work hours in the New York DA's office—in superhero guise. Later, direct exposure to additional gamma radiation makes the transformation permanent.

The invariable focus of the series is the She-Hulk's body. Like all superheroes, she possesses superpowers, and the narrative, of course, centers on their deployment, with occasional diversions having to do with their weakening, temporary loss, and recovery. But the thing about She-Hulk's body and the reason for its salience in the *nonac-tion, non*medical scenes is that she is positively gorgeous. In addition to being unusually tall—her six-foot seven-inch height is specified, and she is almost invariably depicted as towering over everyone else on the scene—she is broad-shouldered and muscular. She also has green skin and blackish-green hair. Despite this coloration and in a world where, let's face it, huge bright-green chicks are not much in demand as beauty-contest winners or even Saturday-night dates, She-Hulk wows the men with a body that is the epitome at once of sexiness and of superheroic strength. She deviates from this combination only when, as happens several times in the series' sixty-issue run, a surge of anger makes her revert temporarily to Savage mode, in which she is even stronger but much less attractive. (There's also a brief period when an exchange of bodies forces her into the shorter, squatter form of her secretary and sidekick, Weezi Grant.) All the rest of the time, she is the cynosure of all eyes, with her babe's body involved in plot and costuming devices that reveal as much as the Comics Code (She-Hulk's ultimate archenemy) allows. In addition to what readers can see for themselves, the "She-Mail" letters from fans—most of them presenting themselves as terminally horny adolescent boys—provide monthly reinforcement of the notion that Shulkie, as she is nicknamed, is not only the top female in the comics, but also the most desirable woman on (at least) this planet.

Desire is really the operative concept, here, for, even as the look of a superhero like Wonder Woman altered with changing popular

canons of beauty and even as those standards became more overtly sexual, neither she nor the other female heroes was so blatantly and insistently represented as an object of desire. Blatantly and insistently and, it must be added, joyously, since, except for episodes in which she is rescued at the last minute from marriage to some revolting extraterrestrial monster, a marriage engineered, in each case, precisely because she is such a perfect specimen of the nubile female, the She-Hulk enjoys sex. Although once their relationship begins, she is represented as faithful to her Native American lover, Wyatt, she also gets a charge out of turning on male characters and readers alike.

So here, in the She-Hulk, we have that elusive combination, the conjunction of two connotations of the female ideal, perfectly strong and perfectly desirable. But is this a feminist representation or not? My response is an unequivocal "yes and no." There is, first of all, her power and the fact that she shows no hesitation in routinely employing it to save innocent people from natural disasters or construction accidents, as well as saving society from one of the most bizarre sequences of (mostly other than human) bad guys to inhabit the genre. In contrast, moreover, to Wonder Woman's graceful, almost delicate maneuvers, which are always represented as essentially defensive and often magical, She-Hulk readily goes on the offensive. And, on one level of feminism, there is something highly satisfying about seeing She-Hulk's fist connecting with the jaw of a certified arch–bad guy.

In addition, her exuberant sexual subjectivity may be read as a declaration of women's right to the assertion of desire. It is rather disquieting, though, that that assertion coincides so seamlessly with mainstream commercial representations of *male* sexuality. It is as if gender equality in sexual terms means merely that women were free to be sexual in the way that, for instance, *Playboy* defines the norm: visually primed, ever youthful, recreational, and exclusively hetero. It is sex as turn-on, and what turns the She-Hulk on is the mirror image of what turns on the boys who drool over her, having a beautiful chest and a great ass. Even She-Hulk's famed "fashion sense" and her

love of shopping enhance this notion of sexuality as being first and last about the most obvious and unsubtle externals.

Judith Butler's theory of performativity is relevant here, even though, appropriately enough, the application of Butlerian categories—to this representation and by me, of all critics—has a distinctly ironic edge. In brief, Butler rejects gender as a fixed category, considering it, rather, a *"corporeal style,* an 'act' . . . which is both intentional and performative, where *'performance'* suggests a dramatic and contingent construction of meaning" (Butler 1990, 130, emphasis in original; see also Butler 1994. For a critique, see Ebert 1996; Bishop and Robinson 1998, chapter 8). Gender identity, she maintains, is constituted through "a *stylized repetition of acts"* (Butler 1990, 140, emphasis in original), which are imitative but have no stable origin (138). That is, the drag queen may be said to be imitating the straight female, but the straight female is also imitating—though imitating *what?*

Just as she is interested in the fluid boundaries of the body itself, Butler focuses her argument on gender performance that is at the margins and is transgressive of societal rules. Although not transgressive in this way, since she is, in fact, defined as heterosexual and female, She-Hulk performs gender precisely as the drag queen does and thus, like that other self-conscious performer, enacts a challenge to the fixed and rigidly anatomical definition of gender at the same time that she seems to confirm it. On another level, it may be that the She-Hulk's large size and musculature, coinciding with her enormous breasts and beautifully shaped legs, even her obsession with costumes and shopping for them, her refusal to wear a superhero "uniform," also reflect her affinities. In encoding herself so blatantly hetero-female, she shows that, in that identity, she has more in common with the drag queen than with the typical straight female—whoever *she* is.

Perhaps, though, there is a simpler reason why the primary assertion that there are such phenomena as female hetero identity and female sexuality and that She-Hulk experiences them (experiences them, indeed, early and often) cannot be discounted. Since the read-

ership is largely male and adolescent, blatancy may be the only way to serve the didactic purpose. The impact of her sexuality, combined with that of her fist and feet, remind us that She-Hulk may like sex, but that she will have it only on her own terms. There is, for example, the moment in no. 25 (March 1991) when she rejects Hercules (yes, the original one from early *Wonder Woman* and classical myth), who has long been the object of her erotic fantasies. After a victory for which he unfairly takes all the credit, he places his arm around her saying, "Come, fair one. Let us celebrate. The rest of the night doth beckon. Ay?" To which she replies, "Get lost. I've had it with muscle-bound morons! What I ever saw in you I can't imagine!" And, when he incredulously refuses to take no for an answer, she hauls off and, "Fwang!" he's history (ancient history, of course).

With his antiquated attitudes (though, in all fairness, what else can he be expected to display?) Hercules reflects a recurrent theme in *The Sensational She-Hulk* that is the principal vehicle for the brand of feminism the series purveys. For instance, an enemy who reappears in several issues is Mahkizmo who, in no. 38 (April 1992) is subdued by Cupid's Valentine's Day arrow, but who is no less macho as a wooer of She-Hulk than as her attempted conqueror. In fact, the sequence may suggest to at least some readers that these are not opposing stances, but rather two sides of the same old machismo (which the Marvel folks appear to believe is pronounced as the phonetic reading of Mahkizmo's name would indicate). In this sense, he is a more developed version of Wonder Woman's old foe the Gaucho.

In the next issue and in an even more political vein, the still-smitten Mahkizmo plans to make She-Hulk his bride and carry her home to the planet Machus, sparing her the fate he plans for the rest of Earth's female population, the "gender bomb" that will eliminate "the . . . female problem." Some time back, the Fantastic Four—"unnaturally" from his point of view—combined Machus with Femizonia, and he seeks to restore "the Before Time . . . the greatest of all possible worlds! Where man ruled!" One of the jokes is that, because all this is happening in a time warp (natch), Mahkizmo is seeking to

destroy women of the past as a fearsome object lesson leading to the resubjugation of the women of his own time. He has to be taught the literal facts of life so he can figure out why the destroyed women would, by definition, produce no descendants to learn the wrong-headed lesson. But She-Hulk has to beat the crap out of him before this educational event can take place.

Replying to fan mail, She-Hulk sometimes says she'd like to have a sister, but sisterhood as a concept is otherwise entirely absent from her pages. Unlike *Wonder Woman* in its feminist moments, *The Sensational She-Hulk* does not teach that sisterhood is powerful. It is *power* that is powerful, and power is most often modified with *super*. In her adventures, She-Hulk is sometimes assisted by Weezi, who is actually the Golden Age superhero Blonde Phantom come out of retirement (to forestall the aging process, since comic book heroes don't grow old like the rest of us), and by Weezi's daughter, Wanda, a clueless eighteen-year-old for whom comic superheroism looks like a "cool" career option. But she has a few female villains, including her archenemy, Titania, to contend with, and, more often than not, the reinforcements in her struggles come from the ranks of the Marvel character family, usually the male Avengers or the male three-quarters of the Fantastic Four.

More important from the point of view of assessing She-Hulk's feminism is that she is so one-of-a-kind that she does not—cannot—share her strength with other women and thereby empower them. Her status as a feminist icon has to rely on conveying the idea and ideal of female strength, rather than on her being a hero to emulate. If Wonder Woman's archetypal message is "Remember Our Power," She-Hulk's is "Remember *Mine!*" In no. 10, however (mid-December 1989), the mass-marketing expert Lexington Loopner evidently thinks otherwise, for he calls She-Hulk "a nearly impeccable role model for the women of the Nineties," explaining to an incredulous green superhero, "You're perceived as intelligent, independent, strong but non-threatening to men, emotionally vulnerable—yet professional enough to manage dual careers, as an attorney and an

Avenger, no less." That "Nineties" ideal, with its qualifications about being "non-threatening" and "emotionally vulnerable—yet professional," might be a better definition of a postfeminist ideal than a feminist one. A similar (and similarly postfeminist) description, this time She-Hulk's simultaneously coy and ironic *self*-description, appears in no. 58 (December 1993), when a desperate man instructs a security guard to "Hurry! Call the cops! Hit the alarm! Get . . ." she breaks in with, "a vital woman of the '90s with hopes, dreams and aspirations of her own?" He cries, "No! An Avenger!" and she adds, "That too."

But the real point is that Loopner inadvertently helps expose the politics of the "role model." He concludes his list of She-Hulk's positive (and salable) attributes by telling her that she's also perceived as "deeply concerned about environmental issues." When she demurs, he explains diplomatically, "We assume it has something to do with the color of your skin." To Loopner, all principles are similarly skin deep, susceptible to cynical manipulation for material or political gain. And, although She-Hulk accepts the assignment to defeat "Pseudomonad," a disgruntled ex-client of Loopner's, she is not looking for the promised PR reward. At the end, she says, "I just can't see getting involved with all that media manipulation and craziness." Indeed, when, in no. 26, she does agree to allow her image to be marketed, it is in a compact with the Devil himself, which, like all such literally Faustian bargains, takes some doing to break.

It's not easy, though, to keep a straight face while discussing whether or not there is feminism in the *She-Hulk* series and, if so, what kind it might be. That's because the principal—and sometimes, it seems, the exclusive—modality of this comic book is a colossal running joke. In addition to the customary Marvel irony and its concomitant sophomoric cynicism, the characters in *She-Hulk* comics conduct an ongoing metafictional dialogue with one another, with their creators, and with the reader (Palumbo 1997). She-Hulk learns from Weezi how to save time by walking from one panel to another;

she argues about the editor's choice of artists and writers for her adventures and with those selected about how they represent her body or design her plots; and she alternately flirts with and challenges the audience. When, in May of 1989, *The Sensational She-Hulk* took up where the *Savage* series, which had lasted for only twenty-five issues, left off, the first cover showed the superhero in all her sexy magnificence holding a copy of the first issue of the predecessor magazine and announcing, "Okay, now this is your second chance. If you don't buy my book this time, I'm gonna come to your house and rip up all your *X-Men*." Sixty issues later, in the final number (February 1994), after ringing what seems to be all the possible changes on a comic book figure's constant awareness that this *is* a comic book she's in, she stands in the identical dominatrix stance holding issue no. 1 of both series and stating, "OK kids, we had a deal. . . . Now hand over those *X-Men Comics!*"

The She-Hulk, of course, did not originate self-reflexivity in the comics, which was a hallmark of Marvel from the beginning. Take *Captain America* no. 1 (March 1941), in which Franklin D. Roosevelt addresses military brass concerned about the Nazi saboteurs and spies who have infiltrated the U.S Army. "What would you suggest, gentlemen?" the president asks. "A character out of the comic books? Perhaps the Human Torch in the Army would solve our problem." But this *is* a comic book, so he summons FBI chief "J. Arthur Grover" (a comic book could joke with the president, apparently, but not with the sacrosanct J. Edgar Hoover, who, in later years, investigated *MAD* for its "subversive" satire!). Grover takes the generals to the underground lab where a skinny young man classified as unfit for military service is being inoculated with a "strange seething liquid." This serum goes "coursing through his blood," the inventor explains, and "is rapidly building his body and brain tissues until his stature and intelligence increase to an amazing degree. . . . There's power surging through those growing muscles—millions of cells forging at miraculous speed!" And so Captain America is born, gets christened, and proves his mettle right there in the lab. President Roosevelt knew

his question was far from rhetorical. What this country needed was indeed "a character out of the comic books."

Metafiction became a recognized Marvel device with the comics renaissance of the '60s, noticeable in the early issues of *The Fantastic Four*, who know their own adventures are being retold to readers in a magazine, through which they are able, occasionally, to break down the "fourth wall" convention and address the audience directly. As the Thing says, the TV news is "for guys who are too cheap to buy our mag!" (no. 18, September 1963). The Four answer fan mail or, in the case of the Thing, challenges from his perpetual tormenters, the Yancy Street Gang (no. 5, September 1962), and, in what was to become another Marvel tradition, readers actually meet Stan Lee and Jack Kirby, respectively the writer and artist for the series (no. 10, January 1963).

Still early on, but on another level, Johnny Storm reads a copy of *The Incredible Hulk* and compares its protagonist to the Thing, triggering an attack of rage: "I'll teach you to compare me to a comic book monster!" cries the comic book monster (no. 3, July 1962). Later, when the top echelons of the military enlist the Four to capture the Hulk, who they are convinced is the Wrecker destroying atomic installations worldwide, the Thing responds to the suspect's picture ("number one on your Hate Parade") with the comment, "He sure ain't no beauty contest winner!" (no. 12, March 1963). And the resurrection of Sub-Mariner (for better or for worse, we're meant to interpolate here) begins when Johnny Storm comes across him as an amnesiac "stumble bum" in a flophouse. Comparisons and recognition begin with the fact that Johnny has been reading about Namor in a comic book when the encounter occurs (no. 4, May 1962).

My favorite from these early days, though, is the series in which the Skrulls make their first appearance. The Fantastic Four, masquerading as Skrulls masquerading as the Fantastic Four (early days means only one turn of the appearance-reality screw), are able to avert an invasion and send the aliens back to their home galaxy. They do this by showing pictures of the Earth's monster inhabitants and invincible weaponry. "I pray he doesn't suspect," thinks Reed, handing

the horrid "photos" to the Skrull in chief, "that they're actually clipped from 'Strange Tales' and 'Journey into Mystery'" (no. 2, January 1962).

From FDR onward, the "real world" represented in Marvel Comics played with the idea of the comic book as a world of the literally incredible. The president commissions the development of a superhero to aid in the war effort while implying that to bring in "a character out of the comic books" is a ridiculous strategy. Twenty years later, Reed Richards, face to face with a bizarre-looking extraterrestrial, frightens him away by showing him monster images from comic books. The real innovation that begins with *The Fantastic Four* is that Marvel characters read comics and are aware that they themselves are participating in a comic representation of their "actual" adventures. Similarly, the creators not only enter into dialogue with readers and allow their characters to do so, but situate themselves as characters in the narrative and even, through devices like the "What If . . . ?" plot, show their creation as a process involving narrative and aesthetic choices. In the postmodern phase, the Four are transported, instead, into alternative universes, with different options for their mutations and identities (vol. 3, no. 47, November 2001).

The She-Hulk takes it all a step further by entering into constant dialogue with her creator about those choices. On the one hand, she has a mind of her own, while, on the other, what she does, wears, and looks like is circumscribed by the efforts of the writers and artists. And even the least thoughtful readers know that it is the writer who is actually putting those critiques of his work into the She-Hulk's mouth. In a similar vein, within a Marvel tradition that revived old names (the Human Torch) and actual characters (Sub-Mariner), sometimes after decades of quiescence, the Blonde Phantom's presence in the She-Hulk narrative takes self-reflexivity to new heights. Weezi has figured out that returning to life in the comics means not only that she won't continue to age, but also that the exercise her comic book adventures entail will help keep her in shape. And, as indicated, it is she who teaches the She-Hulk to break the lateral

boundary between frames, in addition to the fourth wall between action and reader.

It seems to me that all this represents another stage in the process of comic book self-awareness and self-commentary. The simultaneous presence—indeed, the deliberate juxtaposition—of multiple points of view and multiple sources of narrative and visual authority, along with the constant commentary on the process of making the work of art as it is being made, mark the departure as a move in the direction of postmodernism. ("'In the direction,' my green ass!" interrupts Shulkie. "I've set up light housekeeping there!") Moreover, if comic books always and deliberately blurred the line between the reader's universe and that of the comics, *She-Hulk* carried that tendency to a new dimension. Superman visited a wartime relocation camp, Wonder Woman and Mary Marvel recruited for various aspects of the home front, the Thing ranted at "the kids" about selling Invisible Girl short. But with the She-Hulk it's no longer clear whether she is continuously stepping into the readers' space or pulling them into hers. And that, too, is postmodernism with a (comics-style) vengeance.

What was a postmodern novelty in the days of *The Sensational She-Hulk,* a dozen or more years ago, remains an innovation for some. There may be more continuity in the comic book audience than there used to be, but there are always what the cyberworld calls your newbies, as well. Thus, on February 28, 2003, I heard two men in their twenties chuckling over an example of self-reflexivity. Apparently a recently published comic book has one character say to a superhero, "I've always wondered: How do you manage to talk in all capital letters like that?" These two were also arguing—passionately, for their taste in female superheroes did not coincide as well as their response to metafictional wit—about whether whatever hero they were discussing should marry Black Cat. They were yelling at each other across a small shop, so I wasn't exactly eavesdropping, though I did keep a proper academic distance from the debate.

In *The Sensational She-Hulk,* the constant barrage of metafictional commentary reduces ideology, along with everything else, to a

joke about appearances and reality. So, although the She-Hulk sometimes utters quite radical opinions about gender roles, corporate greed, and political corruption, along with more specific jibes at, for instance, nuclear power or Dan Quayle, she stands ever ready to erase those declarations in the next frame and, sometimes, replace them with their opposite—because the whole thing is, first of all, a joke (and second, too, a Marvel wit would undoubtedly interject), and, in addition, a fiction, which is, by its nature, not only a constructed artifact, but an open-ended one, susceptible to constant demolition and reconstruction.

It is this programmed instability in the narrative line that makes *The Sensational She-Hulk* postmodern. But postmodernism takes diverse forms and pursues different directions for other contemporary female superheroes, raising a new range of questions about their place on the fluid boundary between feminist and postfeminist representations. In what follows, I survey the range of postmodern representations within the Marvel universe and outside of it, in order to understand the relation of those representations to changing definitions of feminism. It is only from the end point of this survey that I believe it is possible to raise the culminating question about what constitutes a feminist work of art in any medium and how we know one when we see it.

Although irony is the hallmark of all the Marvel comics, She-Hulk's brand of self-reflexivity is less insistent in the other series. Elsewhere in the Marvel universe, postmodernism is signaled through a chaotic narrative, shifting definitions of identity itself (with some reference to gender identity, as well as other more unambiguously essential characteristics). A mind-boggling combination of New Age or more traditional demonological ideas is combined with those culled from science fiction, mystified cybertechnology, classical myths, and magical folklore to create the polyvalent narrative "authority" that is one vein of postmodernism.

Thus, *The Fantastic Four* no. 367 (October 1991) seems, at first, to be raising some socially based questions about gender within the

institution of marriage. Focus is on the relationship between Human Torch Johnny Richards and his wife, the blind sculptress Alicia Masters. Johnny's unease, his sense of not living happily ever after, and his learning from his sister that the apparently perpetual honeymoon she and Reed Richards enjoy actually takes *work* are clearly connected to a plot in which Alicia's stepfather puts aside his vengeful agenda against the Fantastic Four to enlist their aid in rescuing her from an as-yet-unspecified doom. The motif about an intrusive "alien presence" that the Thing senses among them initially appears to be a subplot with no relation to the gender and marriage issues, much less to the announcement that Alicia is on the verge of making. In another context, it would be the prospect of a Blessed Event that she plans to announce, but what we all learn in the last frame, a full page, as Alicia turns green and scaly before our eyes, is that, as the Thing puts it, "Yer lovin' wife is a stinkin' Skrull." Since her actual identity is as a demonic shape-changer, her gender definition may, in fact, be as unreliable as her species and planetary origin, but the initial message is that it is the female who is what the episode's title calls "The Monster Among Us." And the cover that brings us this title for the first time also adumbrates "the shock ending of the century" by telling us that, in this issue, "the boys are at it again!"

The multiplicity of postmodern perspectives means that this sinister vision is only one of Marvel's perspectives on gender. After all, the group's principal female superhero is Invisible Woman, who, in developing from Invisible Girl, also grew considerably in self-esteem. In *The Avengers* no. 307 (September 1989), Sue and her husband confront an island that needs to be shored up in a hurry, to keep it from falling headlong off its rocky perch, and she asks, "But . . . how? We responded so quickly to . . . [the] alert we had no time to collect any specialized equipment." His reply is direct and to the point: "You're all the equipment we need, honey. Project an invisible force field."

Generally speaking, Invisible Woman does constitute all the "equipment" needed. As explained in the character recap in *Fantastic Four* 3, no. 2 (February 1998), she is

[c]onsidered by some to be the most powerful member of the team . . . [with] the ability to render herself and other objects invisible. Also, Sue has learned to control her power to such a degree that she can use it to create impenetrable force fields and "walk on air" by constructing rising columns of invisible energy beneath her feet. She can even use this shield offensively, projecting solid forms at high velocity toward the opponent.

In earlier times, both as Invisible Girl and subsequently as Invisible Woman, the invisibility was an attribute of Sue herself and was her principal weapon, although she was also strong and flexible. (That is, she was in excellent shape, although she possessed neither the superhuman strength of the Thing nor the superhuman flexibility of Mr. Fantastic.) As the character recap suggests, she later added to her own invisibility the ability—or rather the power—to confer invisibility on other people or objects. The postmodern Invisible Woman can now "project an invisible force field." When she does, the caption says something like "The Invisible Woman concentrates hard" (3, no. 35, 2000). The field serves to entrap, paralyze, and thus neutralize whatever (or whomever) she directs it toward. And, in the absence of much explanation of what an invisible force field is, the phrase is constantly repeated, by Reed, by Sue herself, or by the omniscient captioner, whenever such a field is deployed. It's become so much a Fantastic Four convention that a Skrull who has assumed Sue's shape in order to attack the archvillain Super Skrull (himself masquerading as—what else?—a Hollywood producer), confirms her identity by shouting to the (real) Human Torch, "Don't worry about me, Johnny. My invisible force field will protect me!" before it proves unable to do any such thing. Incidentally, her death reminds us—or else lets us know for the first time, if we're new to this motif—that Skrull blood is green (3, no. 37, January 2001).

The invisibility that was once an extension of Sue's characteristic shyness, although always a positive asset in her superhero identity, becomes a different sort of superpower once she no longer wants or

needs to efface herself. Her more self-assertive personality now turns her invisibility into an offensive weapon. Something may well be being said, here, about transforming into strengths the attributes that have conventionally been understood as feminine weaknesses. And, in the process, a protofeminist icon is created, one who is strong, muscular (if not in the sense that the She-Hulk is), and also attractive. As her powers have grown, moreover, and her self-abnegation is no more, she redefines the stereotyped female role. While visiting the Baxters' Kansas farm, she stops Abigail, who is clearing the table. "Abigail, let me give you a hand with the dishes," she begins. Then, as they go spinning through the air into the sink in the next room, she adds, Marvel irony clearly in place, "It's not quite knocking Doctor Doom on his ass—but I like to keep in shape" (3, no. 38, February 2001).

The character description from 1998 also states, "Sue balances her role as an adventurer with that of a working mother, as she has a young son, Franklin, and is responsible for the day-to-day running of the Fantastic Four's charitable foundation." In this sense, Invisible Woman permits herself to be simultaneously visible as the liberal feminist ideal of the woman who "has it all" and as the feminist bogey the superwoman, who *does* it all. But there's another facet to the '90s image, whether that be ideal or bugaboo. Sue's little boy, who is, after all, the son of two mutants, is said to possess "unimaginable mutant power," including the occasional "ability to create life," which the list of dramatis personae correctly characterizes as "godlike." So Sue Richards, Invisible Woman and superwoman, is also, at least sometimes, the mother of God! Whereas Wonder Woman as Amazon was the direct antitheses of the Virgin Mary, Sue's identity encompasses that icon, too.

Icon is used advisedly, for the issue I have been citing, titled "Heroes Return," with a cover featuring an action image of Sue accompanied by the rubric "Welcome Home, Invisible Woman—Now Die," has a villain called Iconoclast. And the Human Torch gasps out his summary of the struggle this way: "Battle not between Fantastic Four and Iconoclast. Battle between *all* life and *all* death!" If these are really the stakes in this narrative, then Sue Storm Richards has

moved into an even more powerful mythic identity, one the Virgin Mary only dimly reflects: She is the Mother Goddess herself. And the bemused critic (well, this one, anyway) is left asking whether Invisible Woman as the Great Mother is *the* feminist ideal or just another postfeminist gag.

Meanwhile, as if to assert that, postmodernism or no, Sue's development has been absolutely linear, Sue does invoke her earlier self. In a recent struggle against recurrent foe Diablo the Alchemist, the Four, with their combination of science and magic, are joined by Blanca, a young Spanish girl in a well-cut monk's robe. Blanca, a Deaconess, last surviving member of a religious order dedicated to exorcising Diablo's demons, insists on joining the Richardses: "As a lamb to the slaughterhouse I shall go, with or without your approval. This is my *fate*." Sue interrupts her (projected) force field projecting for a moment to remark, "You remind me of a certain young girl, Blanca. She stubbornly preferred to go aboard a starship that would change her life forever. 'Where you go, I go.' Remember, Reed?" And Reed apparently sees no difference between Blanca's religious devotion (at one point, she actually invokes the Virgin Mary in a fragment of prayer) and the young Sue Storm's devotion to him. "How could I forget the girl I married, Darling?" he asks rhetorically (3, no. 35, November 2000). Blanca, by the way, does become the sacrificial lamb in the next issue, having first lost (more precisely, been despoiled of) the sacred document that is her heritage and then, before her inevitable death, sold out to Diablo for what he knows she most desires: physical beauty. No invisible force fields in *her* arsenal!

Membership in the Fantastic Four is restricted by the name and the members' common historical experience, so female representation in it is permanently fixed at twenty-five percent. But the Avengers have a more fluid size and a larger representation of female superheroes. The contingent has included, among others, the latter-day Captain Marvel, the Wasp, the Scarlet Witch, Firestar, and Warbird, as well as the She-Hulk, each with her special powers and defining

characteristics. Over time, some Avengers have become inactive by their own choice or as a disciplinary measure, and sometimes return from that status. ("Once an Avenger, Always an Avenger" is a recurrent motto.) They are subject to external, often alien mind control with roughly the same frequency that soap opera characters are stricken with amnesia. This mind control is a state from which they may be brought back, but the experience leaves scars. Similarly (What do I mean "similarly"? I'm describing this stuff as if it's like dyeing your hair or, at most, getting a nose job!), Avengers sometimes suffer severe alterations in their molecular structure or even, in at least the recent case of the Vision, the loss of the entire body. These traumas can also be healed—or, more accurately, repaired—although this, too, can lead to psychological or existential problems for the individual. (What makes this postmodern, as I will show further on, is not the angst itself, but its relation to the "main" action plot.) Because members may be temporarily or permanently lost, the Avengers recruit, interviewing and testing new applicants and (with more or less difficulty) integrating them into team operations. All these generalizations apply as much to the generations of female members of the squad as to the male.

On the whole, the Avengers have adjusted to postmodernism even more comfortably than the Fantastic Four. This is partly because of the frequent roster changes, but also because their individual identities shift fairly rapidly. The writer and the artist also appear often, with the latter asking the former where to take or when to end a particular theme. (We may drop out of a sequence only to catch sight of it in the next frame as the theatrical looking "flat" on which the artist, brush still dripping, has been at work.) One of the most important differences, however, is in the matter of the various superheros' alienation. Among the Fantastic Four, only the Thing is alienated from at least the external aspect of his mutant identity. He might like being as strong as a rock, but he doesn't appreciate looking like a box of them. And who can blame him? Elsewhere in the Marvel universe,

the Hulk and Spider-Man (who, of course, was briefly an Avenger, himself) get into trouble because of—and have psychological and existential problems with—their mutations. The Avengers are not only made uneasy by their mutations and the mutations that these undergo, all of which contribute to a kind of existential angst, but they also suffer relationship, ethical, and identity crises whose superimposition onto the comic book story sets a postmodern stage. Female Avengers not only experience this aspect of the book's postmodernism, but often embody it.

The Wasp was there from the beginning, with the power to make herself the size of that annoying insect and to sprout wings when this happens. *As* a wasp, she can literally get into the faces of the enemy, but her primary role in the early episodes is to make use of her reduced size to carry messages. (The electronic ID cards and other high-tech communication methods still lay in the future.) Although she is already performing this function from issue no. 1 (September 1963) on, and although it is she who diffidently suggests the name they adopt when, at the end of their first adventure, they decide to continue working as a team, she is not even listed or pictured on the cover as an Avenger until no. 3 (January 1964). That naming scene is indicative. The collective name, she says, "should be something colorful and dramatic like—the Avengers or. . . ." Ant Man, her husband, interrupts, " 'Or' *Nothing*! That's *it*! The Avengers!!" And the other three, their bulk enhanced by the solidity of how they're standing together, Iron Man and Thor with arms upraised in a salute that is not quite fascist or communist, the Hulk between them with arms crossed, add their macho comments: "We'll fight together or separately, if need be!" begins Iron Man, "I pity the guy who tries to beat us!" adds the Hulk. And "We'll never be beaten! For we are—*the Avengers*!" finishes Thor.

It is not until no. 13 (February 1965) that the Wasp's value to the others is put to the test, in an adventure in which, through manipulations on the part of the foe, in this case, the international crime cartel the "Maggia" under the control of Count Nefaria, "the

world turns *against* the mighty Avengers!" (This is a motif that has been repeated so many times in the past forty years that you'd think the world would have figured the ploy out by now.) The Pentagon has already apologized for believing the Avengers could ever be guilty of treason, when Rick of the Teen Brigade shows up with a lifeless Wasp (full size, at this point) in his arms and the concluding panel speaks of the adventure "in life and death" that is about to begin.

The next issue, no. 14 (March 1965), is titled "Even an Avenger Can Die," and begins with the ominous words, "Yes, even to those who have become a legend in their time, death is possible!" And death does come to various Avengers over the ensuing decades, but the Wasp is still with us—although inactive at the turn of the millennium—because emergency surgery saves her, once her teammates rescue the only doctor on Earth with the technique to do so from captivity by a horde of space aliens in an underground city deep beneath the North Pole. In the last frame, this Dr. Swenson announces, "The operation was successful! The girl will recover!" And the text legend concludes: "Let us now leave the Avengers! Strong men should not be seen with tears in their eyes! Nor should they be disturbed as they lift their faces heavenward, in solemn, grateful thanksgiving!" In the mid-'60s, such statements about "strong men" were as commonplace as the Wasp's flirtatious manner or her references to "women's intuition."

At this point, the Wasp is a valued member of the team because she *is* valued, not because she is gifted. Her evolution into an increasingly powerful character parallels the growing integration of female Avengers into the series' action, reflecting the development in the surrounding society of both feminist and postfeminist perspectives. These two perspectives tend to coexist in recent years, with postfeminism as a response to feminism that does not succeed in driving it out, even in a comic book world where, after all, entire plots depend on something's begin driven out by something else, usually an Avenger. The examples of Scarlet Witch, Firestar, and Warbird reflect this coexistence.

A female Avenger who has apparently died since her heyday is the latter-day Captain Marvel, in everyday life a young African American woman. Her superpower enabled her to turn her body into pure energy, such that, in *The Avengers,* no. 233 (July 1983) she can fly the ninety-three million miles to the sun to pick up the additional juice needed to eliminate Annihilus's force field and, in order to get back as rapidly as possible, "becomes" a gamma-ray laser beam for the home stretch. In this episode, the Scarlet Witch, dressed in what looks like a kinky Halloween costume—red, low-cut, and sharp-edged—does little except wring her hands over the plight of her husband, the Avenger known as the Vision. Scarlet Witch was an early recruit to the Avengers (from *X-Men Comics,* where she was forced to do the bidding of the evil Magneto). She joined the team (no. 16, May 1965) with her brother (in noncostumed terms, they are Wanda and Pietro, he being also known as the Avenger Quicksilver; sometimes it is indicated that they are twins while at other times Wanda says she accepts Pietro's decisions because he is the elder).

In *The Avengers'* postmodern phase, Scarlet Witch has become more powerful, more aware of her power, and more central to the team's success. She has always possessed hexing power—it's simultaneously her "legitimate" heritage from generations of witches and a mutation—but these powers acquire more dimensions in postmodern times. Thus, after Wonderman, who joined the Avengers even earlier than Wanda and her brother, dies, Scarlet Witch discovers that she has the power in moments of the Avengers' special need (at least once an issue, in the late 1990s) to conjure him back from the dead. He looks rather fuzzy, but his great strength, intact, is sufficient to turn the tide of cosmic battles. In this period, Wanda has been "not herself," chiefly because of her peculiar relationship with the Vision who, having lost his body in an epic struggle, exists only as a hologram while a new body is being constructed for him in the lab. Since, in literal as well as psychobabble terms, he is not there for her anymore, she feels isolated and drawn to the dead Simon Williams (Won-

derman), who is called the Vision's brother, because he lent the latter his brain patterns for use in the laboratory reconstruction.

Wanda's own power in battle situations gets stronger as she also turns out to be able to conjure Wonderman *without* concentrating. She has even disobeyed a direct order from Captain America, because she felt it was unethical to exploit Wonderman this way, but the next time, he shows up when she has not invoked him. And then, he appears to help the Avengers out of a tight spot when she *cannot* have conjured him because she is unconscious. Finally, when Wonderman, along with other dead Avengers, is being used to fight the living Avengers in an all-out battle, Scarlet Witch goes to her mentor, the wise, aged Agatha, who tells her a great deal about her background and then explains what has been obvious to the reader for months, that Wonderman appears when she needs him, because he loves her, and that the way to redeem him from the false path he has temporarily taken as well as from death itself, is to love him in return (3, no. 10, October 1998). Which, eventually, she does. But there is still her unresolved relationship with the Vision, so more angst is distributed among all the superheroes. (They can fly, they can channel cosmic energy, they can tear down the strongest walls, but they can't consider a nonmonogamous relationship!)

Meanwhile, Scarlet Witch, whose other powers, as I have suggested, have also been growing and becoming more focused, is asked by the other Avengers to take over as deputy leader, serving during the (protracted) absence of Captain America (3, no. 13, January 1999). The meeting where the offer is made is interrupted by an emergency, during which she displays impressive generalship—military, executive, and humane. Then, when Thor raises the issue of leadership once more, her thought balloon contains a sequence of ideas that belongs rather more to feminist discourse than to that of adventure comics: "I recently considered leaving the team—I felt disconnected, like I was only tied to the Avengers by my relationships—but to be *deputy leader*—to take a more active role, to matter on my own, and

not as part of a couple—" It ends with her saying aloud, in the next frame, "Okay, I'll do it." Throughout this sequence, no one mentions, much less questions the suitability of a woman for the official leadership role, any more than they challenge her authority during battle.

All these questionings of identity and relationships occur during but even more *between* the epic combats. Although they too follow a set of conventions, they are nowhere near as stylized as the battles, and increasingly provide the adventures' real narrative structure. The postmodern element as Marvel frames it is precisely that the epic battles that are supposed to be what the story is about are always the same stylized wars of the worlds, whereas the existential dilemmas of the characters, which would be merely value-added (or even boring) in the comic book genre as originally developed, have become the actual narrative force. The angst theme in itself might be late- rather than post-modern, but it seems to me that its peculiar relationship to the combat stories brings it into (as it were) the postmodern camp. Thus it is that, after Captain America's return and some frustrating adventures, Scarlet Witch approaches the leader with a proposal that she's come up with as deputy. The Avengers all have their troubles, and she lists them as part of the group's problem, "but in the end, I have to say I think it's a failure of leadership." She therefore suggests that he continue as field leader "since you're the best there is—while I take on the role of 'Morale Officer,' working at bringing the team closer together."

So the Avengers have moved from psychobabble to motivational-seminar speak, and it's not clear if we're supposed to find it amusing that this discourse is deployed among a motley, costumed group of mutants with secret and superheroic identities, and their interlocutors, who are neither business rivals nor customers, but robots, extraterrestrials, and the living dead. Scarlet Witch explains the new arrangement to the team, while clad in her Avenger outfit, which is to say, wearing long red gloves, a red bustier that pushes her breasts upward into a deep cleavage and leaves her midriff bare, and low-slung harem pants with chains at the hips. And, once again, neither she nor

anyone else seems to notice any incongruity between her gender, her garb, and her new position of (mediating) authority. This feminist revolution is like that tree falling in the forest: if no one notices it, was it really a revolution?

Scarlet Witch's first act as morale officer brings in another set of gendered issues, by way of another female Avenger. From now on, she announces upon taking office, the chairmanship (*sic*) of the weekly team meetings will rotate, and she appoints one of the newest members, Firestar, to run this first session. "Uh . . . *now*? I mean, sure, I—" is the girl's initial response as she turns to her boyfriend, Justice, another new recruit, and, addressing him by his "civilian" identity, asks, "You, um, don't *mind*, Vance . . . ? And Justice says, "Go ahead, honey, you'll do fine." Which she does, competently facilitating a parody of every meeting you've ever been to, complete with an audiovisual chart of all the monsters and other baddies currently at large (3, no. 15, March 1999).

Firestar (whose real name is Angelica) and Justice have just moved up to the Avengers from a "minor league" group of costumed law enforcers. At first, she is uncomfortable in the new status, while he is awed and excited at being among his lifelong heroes. In their first major combat as Avengers, before we know much about them, Vance urges Angel to use her "microwave powers" (this is not supposed to make you giggle, so stop it!). "But," she demurs, "when I use my powers at *that* kind of level—" Captain America assures her it is her decision to make, but she screams, "Blast you, Vance! BLAST YOU!!" as she unleashes them. The next text band tells us, "The young mutant feels the power surge through her body—boiling up through her every cell," and the deed is done. Two pages later, Vance is apologizing like anybody's boyfriend—to a point: "C'mon, Angel— I'm sorry I was a jerk. But you saved the *world*. The *whole freaking world*. That's gotta count for *something*, right?" To which she stiffly replies, "It—*had* to be done—I guess" (3, no. 6, June 1998).

In the next issue, Firestar has a conversation about heterosexual relationships with Power Princess, a superpowered extraterrestrial, as

they are flying off on a mission. It's about whether she is sacrificing her own needs to the wishes of her fiancé or compromising at an appropriate and necessary level. Thanked for her help, Power Princess replies solemnly, "My people's philosophy holds that there is more to doing good than simply fighting evil." But she interrupts her own summary of this girl talk with, "Speaking of evil, I have spied our quarry." And Firestar adds, "Back to the fighting then, huh?"

It is not until some issues later that we learn, in another (mutant) woman-to-woman session in which Firestar confides in Scarlet Witch, that her reluctance to use her powers at full strength stems from the resultant radiation buildup that could eventually sterilize or even kill her. Once the Avengers' lab gets on the job, creating an insulation suit to wear under her costume for six months, she is entirely won over and embraces the Avenger identity with her whole heart. The sullen girl has become a fighting woman. Meanwhile, Vance is the one who cannot overcome his nervousness at finally being a real Avenger and, because of Angel's initial alienation from the team, thinks it will be a cinch to convince her to return to the superpowered squad from the old neighborhood.

The problems these two have as a couple, stripped of references to mutation, dual identities, and a most unusual career path (*can* they be so stripped? Well, postmodern Marvel constantly requires the reader to do so) cover familiar gendered ground. He recognizes her right to a "professional" identity of her own, but prods her to perform in a way that will make him (as well as, admittedly, herself) look good to their superiors. She constantly turns to him for affirmation and decision making, readily gives in to his wishes—but then is open to questioning whether all the giving *should* be on her side. The trade-off on her low self-esteem is that the dynamics of the relationship (Cheezt! Now *I'm* talking like that!) allow her to indulge in childish fits of stubbornness and negativity. It is when she outgrows these and acts like a mature, independent woman that the real relationship trouble looms.

All this happens, as it were, right before the reader's eyes. It is presented empirically, the same way that intergalactic combats are, and no context is suggested for their personal agon, so the notion of feminism cannot be included in such a context. As with the Scarlet Witch's accession to a leadership position in her own right, there is no struggle, no male superhero with a foot in the old ways. (Not even the medieval-minded Thor, who takes a rather Luddite view of the Avengers' high-tech arsenal, objects to elevating a woman to the captaincy or rebels under her direction.) The clear implication in the Marvel universe is that the firm's series were once mired in sexist assumptions and stereotypes that, instead of simply burying, they rewrite, as Sue and Reed Richards reinterpret her "whither thou goest" statement of the '60s to suit late '90s prejudices. They were there, now they are here. No bumps, inconsistencies, or revolutions along the way. Postmodernism need not be postfeminist, but this vein of it certainly looks as if it is.

Another version of postfeminism occurs in the story of the Avenger known as Warbird, aka Carol Danvers. (Her Avengers sobriquet comes from an airplane. Maybe everyone but me already knew this.) In an extended sequence in 1998 and 1999, Warbird is clearly troubled, but will admit her problem neither to the Scarlet Witch, who extends sisterly concern, nor to Iron Man who, as a recovering alcoholic himself, recognizes one in her. Carol has not had an easy time of it. She's recuperating, for instance, from a period of alien-instigated genetic modification that has left her half human and half Kree, another bout of intense mind control (during which, under her previous Avengers name, Ms. Marvel, she was turned against the team), and the breakup of a relationship. Nonetheless, she has an impressive career or series of careers behind her, for a woman who is still quite young. She joined the Air Force because she loved planes, but also because her father didn't believe in college for girls (one of the rare Marvel references to an actual gendered issue), rose to the rank of major and was the youngest NASA security chief in history,

and also had a period as editor of a women's magazine, in addition to her two tours of duty as an Avenger, separated by that mind control. She is not only genetically modified, which has endowed her with the (alien) Kree warrior's strength, skill, and flying ability, but during her period of recovery with the X-Men, she was captured and experimented upon (again!) by aliens, so that the full power of her mutation was released. As she explains it: "I became binary—able to channel the energy of a white hole, to fly unaided in space. The stars were mine." She feels—and here the reader might agree with her—that all she's gone through (and I have only hit the high points, believe me) entitles her to a drink once in a while. We see her typical alcoholic's self-delusion, however, when she claims, "The energy in my metabolism burns it off right away" (3, no. 7, July 1998).

Warbird screws up by failing to go binary when that was what was called for, and then trying to win back her standing with Captain America by summoning only him and not the rest of the Avengers to an emergency. When she succeeds despite disobeying orders, she is boastful, when she fails, she is defensive, claiming the Captain has always had it in for her and is looking for an excuse to get rid of her. She is definitely not a team player, but a star who only sometimes exercises star power. Her alcoholism has, in fact, taken its toll and, when she finally does try to use her full strength to combat a lethal situation she has created, it doesn't work as planned. "And all of this," she says in one frame, "because *I* got blitzed—because I busted in here and set this off? No—it *can't* be that way!" In the next frame, she is flying upward, "I won't LET it!! I won't *let* this happen! . . . Maybe there's no way to break through a vibro-field—but I was channeling a *star* not long ago!—and if I can absorb and channel that kind of power, then—NNH—this is—NNH—NOTHING!" And she does break through, but, instead of helping, that makes things worse ("the vibro-field must have been the only thing holding the building up"). Warbird exacerbates the harm she has done by pursuing the malefactors rather than trying to protect the lives she has endangered. In the interest of promoting herself, she violates the basic

Avengers precept, which is to save innocents first, catch the bad guys afterwards. Later still, she battles the Kree while drunk and manages to win ("Don't need control, got power. See?").

Not only does Carol claim that all charges against her (she's actually court-martialed and unanimously demoted to inactive status) are motivated by personal animus, she eventually claims that the source of that animus is her sex: "everyone" is against her because she's a woman. The reader has seen Warbird mess up big time—abusing alcohol and, under its influence, misusing her powers, placing her own status above the mission, misjudging those who offer help. So we know that sexism is not behind the concerted judgment against her. And we are not meant to inquire about the cases Marvel doesn't show us, where women *are* the objects of discrimination. Once again, the move has been from prefeminism to postfeminism, without a stop at feminism.

Geoff Klock maintains that Promethea, a transsexual hero who first appeared in 1995, is

> [a]n attempt to write a genuinely feminine [*sic*] superhero narrative, reversing a trend in superhero literature that sees a female hero as a male character, a male mentality, drawn with a stereotyped female body. Women superheroes traditionally are, or were, simply objects of sexual voyeurism, more pinup girls in capes than genuine characters. . . . Even visually, *Promethea* is an indictment of traditional women in superhero comic books; she stands as a full-bodied woman against the traditional depiction of female superheroes as huge-breasted figures with slim hips. Promethea is Wonder Woman as Wonder Woman could have become, a powerful heroine in her own right, rather than something for young male readers to ogle (2002, 111–112).

Wrong again! Aside from the egregious use of terms like *feminine* and *male mentality* as if they mean something—and the same thing to writer and reader—this statement misses the irony in claiming that a character he describes as "literally" a man in a woman's body is the most real woman of all. And, although it would certainly be nice to

see a variety of body types valorized among female superheroes, to identify one with wide hips who is nonetheless incapable of child-bearing as the "real" woman only increases the unconscious irony. More important, though, it represents abandonment of a postmodern perspective and a consequent failure to read correctly all the other female superheroes, new, continued, and revived, acting solo and in mixed or all-female teams, precisely because they do possess babes' bodies.

One such recent Marvel series featuring a female superhero—this time, one without a history going back for decades—was *Elektra,* whose issue no. 19 (June 1998) is also the last "at least for now." (Given the tendency of the group to try again with unsuccessful formulas, that qualification may be more than a sop to a disappointed minority.) Elektra is described in the prefatory material to this last issue as "Bad girl. Rejected by the light," and also as "a new super-heroine on the verge, using her superior martial arts skills to fight her way toward redemption." We also learn from this summary that

> Elektra once defined herself by the men in her life: daughter of a powerful Greek diplomat who was assassinated, and girlfriend of Matt Murdock, aka the super hero Daredevil. When tragedy struck and her father was killed, Elektra fell into the darkness.
>
> As a member of the Hand, she used her powerful martial arts abilities to become a master assassin. Now she's torn between her blood lust and redemption!

After Matt Murdock's failure to save her father while rescuing her, Elektra could "never feel the same" about this man who had been "her first and greatest love." He remains a character in the series, but her current love interest is a black man, Mackinley Stewart, a former heavyweight contender, who now runs the inner-city martial arts dojo that Elektra funds.

Elektra is in the Marvel tradition of hard-bodied representations with enormous bosoms, thighs of steel, and the longest untamed hair yet, but she is also like Wonder Woman (and even more like Batman)

in being essentially self-made and highly skilled, rather than mutated into superpowers. It is worth noting that, in contrast to the She-Hulk's sexual attitudes, the sect that, in the final panel of this final issue, Elektra vows to restore is known as the Chaste. The last letters page explains that the sales on this title "have been lousy for months." So the question arises as to what it was about *Elektra* that failed to attract the mass comic-buying audience. It's possible that the series went too far in too many ambiguously postmodern directions at once—including the postfeminist ones—leaving the reader in a murky ambiance with no moral or narrative certainties to hold on to. Maybe the comics audience just wasn't ready for a black-white love affair—although it has been known to accept interplanetary and interspecies relationships, and, with She-Hulk and Wyatt, a green-red one! Or maybe *Elektra* was too feminist in the superhero's refusal to define herself by the men in her life, yet, at the same time, not feminist enough, given the many and complex levels on which females *including* Elektra are demonized in the series.

The postmodern female superhero also flourishes outside the Marvel group, of course. *Xena, Warrior Princess*, seems to have a younger audience than many contemporary comics, including more preadolescent and adolescent girl fans. This appeal to the "girl power" generation, along with *Xena*'s status as an up-to-the-millennium success story, makes it imperative to mention the book in my survey, even though *Xena*'s primary venue is the television series. In fact, from the print version, it's hard to figure out what all the fuss is about. (Maybe the very ability to get back into the mindset of the nine-year-old I was more than half a century ago precludes my identifying with today's nine-year-olds.)

Xena's contribution to the postmodern comics is discursive, rather than visual. The artwork, in fact, is a throwback to a style that flourished in the late '70s and early '80s, whereas the language is a deliberately anachronistic mess, imposing colloquial expressions and teenage Valley-speak on characters who are dressed in a stylized version of ancient garb and who have the names and sometimes the other identifying attributes of major figures from classical mythology.

Thus, in "Trial by Torment," volume 2 (March 1998) of the trilogy *Xena, Warrior Princess, vs. Callisto,* Cassandra, the very Trojan princess cursed by Apollo by having her invariably correct prophecies met with disbelief, says, "Oh, I just knew this was going to happen!" (well, of course she did!). To which Xena's sidekick, Gabrielle, replies, "Don't keep saying that! And for the gods' sake don't predict anything else!" Later, when Cassandra predicts that if the prison guards holding Xena and her allies captive try anything with her, "my friend Gabrielle will bop you over the head!" the men's curse-inspired disbelief in the bopping that in fact does ensue two frames later causes one of them to explain, "Don't be stupid, wench!" as the other adds, "Yeah, like we're really gonna believe some dumb female's waiting around the corner to ambush us!" Meanwhile, Xena tells her cellmate, Pandora, that she feels "lousy about everything." And, when the Warrior Princess, under Callisto's psychic power, relives all the bad moments in her life, she cries out, "No . . . don't set fire to that village again," only to have a guard comment, "Oh great! Now she's going into re-runs!"

On the level of this single joke with its self-reflexive implications, *Xena* never fails us. And, of course, there are lots of female characters who are good fighters, all of them sexy, strong, and in the case of both Xena and Callisto, muscular as well. And Xena is a brooding superhero haunted by a past in which she "did evil." Still, to the jaded reader it all seems, somehow, rather *thin*. As does *Shi: Heaven and Earth*, a series begun in April 1998 with a Japanese warrior-caste setting and a brutal religious-wars theme. This despite visual scenes steeped in such highly sexualized violence that it lacks the Comics Code Authority Seal of Approval.

The presence of that seal, minuscule though it is, on the cover of *Supergirl* no. 22 (June 1998) should have been ample warning that I was misreading that cover, on which the eponymous superhero is holding hands and exchanging a lusty glance with a slender figure whose silver hair is even longer than her own and whose elegant fuchsia-and-silver armor seems to be curved to accommodate neat,

round breasts. As it was, I barely had time to let loose an "Aha! A lesbian image in the comics mainstream!" before the text on the first page informed me that Comet, the lovely lover with whom Supergirl is shown locked in an embrace, is actually a man. After all my viewing of comic book armor designed to show off the breasts of women warriors, I had misinterpreted the horizontal bulges on Comet's breastplate and read far too much into the flowing hair. It turns out, in fact, that the androgynous appearance of Supergirl's new squeeze is not the most striking fact about his body. Product of a genetic engineering experiment in "animal crossbreeding" after a riding accident left him totally paralyzed, he has a lot of equine characteristics, including legs configured like a horse's—although there are still only two of them—and hooves to match. Implicitly, it's OK for her to lust after a horse, but not a woman! And how many readers in 1998 could be expected to know about the abortive romance, nearly forty years earlier, between Supergirl and her (you should pardon the expression) mount, Comet the Super Horse?

Next to Comet's special traits, Supergirl's powers don't look all that impressive. In the revived version, she appears human, not Kryptonian, and therefore lacks many of Superman's assets, as well as his Achilles' heel, the vulnerability to Kryptonite. Her ability to fly comes not from within, but from "wings of angelic fire" with which she has been endowed and that make it possible for her to engage in a number of impressive maneuvers, both in the air and underwater. In this issue, which involves a grotesque fantasy treasure hunt ending with the bad guys' being nuked by a booby-trapped "treasure," she and Comet engage in quite a lot of that old mutual rescuing. But next time, we are promised a change of pace as she and a "guest star," Steel, "try to ease racial tensions at a college" and, for all we know, Comet may have galloped off the scene.

The visual representation of the new Supergirl corresponds more to the image of a midwestern teenager named Linda (her secret identity and that of the original Supergirl, as well) than to that of a superhero. With the notable exception of the long, flowing red cape, which

seems to *turn into* the wings of fire, her uniform resembles the cheerleader's costume one would expect this pageboyed blonde to wear. Like any cheerleader, she is clearly in good shape—in both senses of the term—but not muscular. But she certainly isn't turning any cartwheels over masculine prowess and, unlike male feats on the playing field (which I admit I'm interposing here in response to the cheerleader look), her athletic abilities are not an end in themselves but the means to achieve moral and social goals. I just wish I could like her better!

This excursion through one way that DC has dealt with postmodernism brings us back full circle—to *Wonder Woman*. More specifically, to the Amazon narrative in *its* postmodern avatar. As of the late '90s, the individual responsible for story, pencils, inks, and lettering on *Wonder Woman* was none other than John Byrne, the man responsible for nearly half of the *Sensational She-Hulk* issues and the person credited with its greatest successes. (When he left *She-Hulk*, his departure was attributed to death from tripping over a dangling subplot.) Each of the covers from that period says the issue is "by" Byrne, and the first page of each, which lists his contributions to the book's narrative and visual dimensions, also carries a box crediting William Moulton Marston with the creation of *Wonder Woman*. So not only was the pen that brought the She-Hulk to her peak now at work on an evolving Wonder Woman, but in the very midst of this evolution, an insistent homage was paid to the Amazon's feminist originator.

Byrne may not really be falling over his subplots, but the reader entering *Wonder Woman,* in the late 1990s, in midflow, as it were, is liable to be confused by the number and complexity of simultaneous narratives. The postmodern storyline is bolstered by an equally complex set of influences, references, and characters. Olympian theology, with the Greek gods and their Roman versions deliberately melded, is supplemented by the presence of the "new gods," as well as by Merlin and Morgan LeFay from the Arthurian legends. And there are evil scientists and doctors, the longtime cyborg enemy Egg Fu (clearly, no longer young), and intergalactic conspiracies. The Amazon's old

flame Steve Trevor makes a cameo appearance in 1998, with his wife, Etta (the once-fat and giggly Holliday girl), having apparently parked a plane on some unsuspecting citizen's lawn in the middle of the night. Now, Wonder Woman was finally married to Steve in a ceremony performed by Zeus himself, back in 1986, just before *The Crisis on Infinite Earths,* by supposedly clearing everything up, cleared the way for postmodernism. (But not for bigamy. That marriage is apparently one of the things left behind on the far side of *The Crisis.*)

There are also glancing references to actual issues raised by the contemporary feminist movements; in mid-1998, it was domestic violence, in the history of a new Wonder Woman ally, Donna, who mysteriously rejects her last name, Troy. (Another continuing character is a woman who teaches classics at Harvard [who's somehow involved with Merlin] and her teenage daughter, the Wonder Kid [not a Tot or a Girl, this time], to whom Zeus has given certain powers, including that of flight.) Meanwhile, at least one of the original "girls," George or Georgia, has become a computer whiz and eliminates the mind control consequent upon Egg Fu's having connected all their computers together.

All these elements appeared in four issues, nos. 127, 129, 130, and 133, bearing dates from November 1997 through May 1998, and none of them was the main plot. Rather, the actual plot in the two earlier issues centers on the bodily death and transfiguration of Wonder Woman, who ascends to Olympus to become Goddess of Truth (but gets into trouble there because of her continuing concern with what's going on in the Earth-bound plot), while being temporarily replaced as Wonder Woman by her mother, Hippolyte. The latter two issues involve time travel, when Polly (Hippolyta-as-Wonder Woman) takes the Flash back (flashback, get it?) to 1942, to join the rest of the Justice League in making a minor alteration to history, while refusing to destroy Hitler and the other Nazis, which they have the opportunity to do, but which would be too disruptive of the actual course of historic time. Around the turn of the millennium, Wonder Woman moved her base of operations out of Boston to a fictional town and

added some new supporting cast members, including a new man with whom to carry on a platonic relationship. More recently still, she has moved to New York, to represent her native island at the United Nations and become romantically involved with an African American UN employee. But this kind of change is intrinsic to the postmodern phase, which continues at the same pace and with the same complexity as before.

In the most recent version, a six-part series called "The Game of the Gods," in progress as this book goes to press, *Wonder Woman*'s cosmology of multiple pantheons, old and new, combines with a "Dark Side" theme, wherein a malevolent central intelligence, the "Shattered God," seeks to conquer, destroy, and then re-create the universe under his sole domination. It is a measure of the special place that Wonder Woman occupies in contemporary culture—inside and outside the world of the comics—that this series was announced to the media, which ran features in daily newspapers and on TV, as well as in *Ms.*, highlighting the superhero's new look (she cuts her hair and, until part 3 [no. 191, June 2003], suffers from loss of her memory, many of her Amazon powers, and the uniform and accoutrements associated with those powers).[2]

What happens to Wonder Woman makes news, these days, although inordinate attention was devoted to the hair and the outfit, less to the problem of reacquiring her identity and her memory, none at all to the cosmic struggle responsible for the changes. In that struggle, the Shattered God, who evokes the discourse of *Genesis* (we are actually told twice in part 5 [no. 193, August 2003] that "the earth was formless and void"), is annihilating all the pantheons—not only Olympus, but the gods of the Indian subcontinent and of Africa, as reflected in a worldwide drought that is destroying vegetation and, eventually, human life. And the Amazon inhabitants of Themyscira (known in common speech as Paradise Island), like their Olympian patrons, have been turned into statuary representing their former selves. Once she destroys the sole survivor, the goddess Diana, who, wearing Wonder Woman's bracelets, has gone over to the other side

to avoid being reunited with Artemis to (re-) create a single deity, Wonder Woman must face the Shattered God, whose scenes are drawn in the cosmic-battle style familiar from other comics. Despite the enormous odds in a struggle she still does not fully understand, Wonder Woman will, of course, win out (I say this with confidence, although the final episode has yet to appear). There is no doubt that both Olympus and Themyscira will come back to life, with Wonder Woman continuing as a UN ambassador. And that the aid of African American Trevor Byrnes of the UN's Rural Development Agency, will serve to cement their love. Blond Steve Trevor, WASP army intelligence officer, is no longer on the scene, his surname appropriated for the personal moniker of a beautiful black man whose looks even the Paradise Island Amazons admire and who is devoted to saving the Third World while engaged in a relationship with Steve's former love that goes deeper than the earlier comic could ever have imagined, even though William Moulton Marston continues to be honored as the original creator on each monthly title page.[3]

Where is the feminism in all this? Well, there are empowered females all over the narrative, from Harvard faculty brats to goddesses. Their powers, moreover, embrace technology, as well as physical skills and magic. Although there are tensions in Wonder Woman's new "Amazon" band, as well as some female archvillains, there are also many examples of highly effective cooperation among women. Both Diana and Hippolyte have superbodies that combine sexiness and strength to the nth degree. And, with references like the one to Donna Troy as a formerly battered wife, there is a vivid reminder of what happens to *dis*empowered women in the world out here.

So the postmodern devices do make *Wonder Woman* postfeminist, but this time in the sense that, say, postcolonialism is a direct extension of colonialism, rather than its antithesis. They serve, too, as a constant—if chaotic—reminder that seeking out feminism in works of visual or narrative art (or in mixed-media events like comic books) is about the politics of stories. It is not that we expect the works to

tell us a simple or a single story that we passively absorb and act on, but rather that narrative becomes part of the information we use to process our other experience and live in it. If all the sources of narrative tell the same story about women—as in the postwar propaganda effort mentioned in my discussion of *Wonder Woman's* decline—even a slight deviation in the line (say, one righteous Amazon) serves to present other possibilities.

In the present postmodern cacophony, when issues about gender and sexuality are central to the ambient social noise, the stories to be told and the uses we as audience make of them have necessarily become increasingly diverse. The question remains—and, to me, it is a fundamental and troubling one—as to whether the many narrative and stylistic variations to which the postmodern comics expose us merely substitute form for content, new ways of reiterating the now less than revolutionary notion that women can be powerful and that there is nothing left to prove or fight for. If this version of superheroism is no longer enough, what further stories might a comic book Amazon tell us—and provoke us to tell?

Notes

1. I do realize that, in addition to musical, bowel, and social movements, there are artistic ones—like impressionism or surrealism—but the present phase of adventure comics doesn't qualify under that rubric.
2. Another indication of Wonder Woman's unique place in the culture may be found in the mass of licensed products reproducing her image. Where once Wonder Woman stood austerely aloof from the world of commerce, she is now fully entrenched therein. Les Daniels's *Wonder Woman: The Complete History* contains illustrations of some of the more bizarre artifacts of the modern period, and postmodern products have added a touch of irony to the idolatry. Thus, for the past two years, a Wonder Woman calendar has graced my office wall, providing me with slogans to encapsulate my own unquestionably feminist, postmodern, and ironic moods and desires. ("Great Hera," cries the Amazon in February, "I've turned into a baboon!" While May's solution to a temporary miniaturization of the superhero is "I know! I'll hide in

this pretzel!") Meanwhile, in the room at home where I am writing this, I have a pack of Wonder Woman postcards, a box of blank Wonder Woman note cards, a pad of foldover Wonder Woman stationery, a Wonder Woman notebook/diary, and a lunch box, once filled with cookies packaged therein by a superb local bakery—all of them recent gifts.

3. I was wrong in one respect. Part 6 allows the real world and its multiple pantheons to be saved by the sacrifice of beautiful, caring, committed Trevor.

Afterword

SEVERAL TIMES IN THE COURSE of this book, I have mentioned the stories that remain to be told—implicitly, the other stories that female superheroes should be telling us. The reader who has come this far knows that "should" is not about the imposition of rules so much as it is about my own hunger. "If you want to send a message," Samuel Goldwyn is credited with pronouncing, "contact Western Union." But mass culture does send messages. What Goldwyn meant is that he and his fellow moguls were in the business of business, the business of making money. Moreover, a "message," to him, meant an oppositional message, whereas the ones his products sent simultaneously reflected and shaped the status quo—flagrantly so where gender and sexuality were concerned. We also know that the message sent is not invariably the message received. If nothing else, my own reading practice at age six is a model of the kind of resistance to which I refer.

Comic book publishers have been caricatured (in comic books themselves) as a (much) cheaper version of Hollywood moneymen, guys with cigars clenched in their teeth, wearing hats indoors, hawking a product that initially sold for a dime apiece and now, with inflation, remains a penny-ante operation—not guys who care about imagining and telling new stories about gender. But it was these guys, some of them, who gave the ideologue Marston a chance to become Moulton and let Wonder Woman show us what a girl could do, who let Invisible Girl become a woman and Scarlet Witch a general. Their Canadian counterparts, unable, during World War II, to import an

American product deemed "not essential," gave us "Nelvana of the Northern Lights . . . [who] protected Canada's Inuit from the evil encroachments of the Kablunets (from the Inukitut word . . . meaning 'white man.')" (Ferguson 1997, 169). Present-day comic books, as I have been trying to indicate, are postmodern chiefly in that, although they belong to the science fiction genre and follow rigid conventions with regard to that part of the story, which is virtually the same, issue after issue, they actually decenter the narrative away from the sci-fi wars toward the individual lives and consciousnesses of the superheroes themselves. And they have proved postfeminist, in my definition, by depicting a "present time" where gender equality flourishes and where accusations of discrimination are baseless, all without showing us how such conditions came to pass. Or, since they haven't done so in our world, how we can make the changes we need.

Anyway, the decentering of the narrative leaves room for social issues that do *not* involve alien attempts to destroy the universe or mind-control our heroes. And the kind of postfeminism that suggests all gender problems have been solved will not stand up to the merest outline of what remains to be done. In the last chapter, I remarked with some irritation that the Avengers could imagine a woman flying or channeling the stars, but not involved in a nonmonogamous relationship, even if one of her partners is conveniently disembodied. Earlier, I expressed impatience with the fact that Supergirl could have a partially equine lover, as long as it was clear he was a male. A same-sex relationship is apparently not imaginable. What about a happy, productive celibacy? (Well, I'm not crazy about that one, either, but surely it depends on what—or who—is the alternative.) And what about flying through the glass ceiling? About recognizing (nonsuper-) powers in the *mass* of women? About domestic violence? Date rape? Pay equity? Incest? (After all, Batman took on child prostitution—strangely, but he did it.) Unwanted pregnancy or infertility? Sexual harassment on the job—or in the street? The plight of domestic workers? Sweatshops? What about solidarity, collective action against monsters that aren't bug-eyed? Some of these stories are easier to imagine in the

comic books' present yuppified milieu than others, but that is no excuse for telling us none of them.

Yes, we can build dreams of power with the materials the comics have given us. But that does not mean we couldn't do more with stories in our heads about social issues like the ones I've listed and with new dimensions of myth added to our arsenal. Why—why—we could all be Wonder Women, just as Charles Moulton/William Moulton Marston told us we could.

Works Cited

Ariosto, Lodovico, *Orlando Furioso,* 1516; trans. Allan Gilbert. New York: S. F. Vanni, 1954.

Bishop, Ryan and Lillian S. Robinson. "Batman Goes to Bangkok," review of *Batman: the Ultimate Evil,* by Andrew Vachss, *The Nation* (January 29, 1996), 34–35.

——. *Night Market: Sexual Cultures and the Thai Economic Miracle.* New York and London: Routledge, 1998.

Butler, Judith. *Gender Trouble: Feminism and the Subversion of Identity.* New York and London: Routledge, 1990.

——. *Bodies that Matter: On the Discursive Limits of "Sex."* New York and London: Routledge, 1994.

Chabon, Michael. *The Amazing Adventures of Kavalier & Clay: A Novel.* New York: Random House, 2000.

Daniels, Les. *Wonder Woman: The Complete History.* San Francisco: Chronicle Books, 2000.

DeLillo, Don. *White Noise.* New York: Viking Penguin, 1985.

Ebert, Teresa L. *Ludic Feminism and After: Postmodernism, Desire and Labor in Late Capitalism.* Ann Arbor: University of Michigan Press, 1996.

Edgar, Joanne. "Wonder Woman Revisited." *Ms.* 1:1 (July 1972), 52–55.

Eisler, Riane. *The Chalice and the Blade: Our History, Our Future.* San Francisco: Harper and Row, 1987.

Ensler, Eve. *The Vagina Monologues.* New York: Villard, 2000.

Feiffer, Jules. *The Great Comic Book Heroes.* New York: Dial, 1965.

Ferguson, Will. *Why I Hate Canadians.* Vancouver: Douglas & McIntyre, 1997.

Fraser, Antonia. *The Warrior Queens.* New York: Knopf, 1989.

Gilman, Charlotte Perkins. *Herland,* 1915; reprinted, edited by Ann J. Lane. New York: Pantheon-Random House, 1978.

Kingston, Maxine Hong. *The Woman Warrior: Memoirs of a Girlhood Among Ghosts.* New York: Knopf-Random House, 1976.

Klock, Geoff. *How to Read Superhero Comics and Why.* New York: Continuum International, 2002.

Marston, William Moulton. "Why 100,000,000 Americans Read Comics." *American Scholar,* 13: Winter 1943–44, 35–44.

Mattelart, Armand and Ariel Dorfman. *How to Read Donald Duck: Imperialist Ideology and the Disney Comic,* trans. David Kunzle, 1971; 2nd edition, New York: International General, 1984.

Palumbo, Donald. "Metafiction in the Comics: *The Sensational She Hulk,*" *Journal of the Fantastic in the Arts,* 8:3 (1997), 310–30.

Richard, Olive, pseudonym of Olive Byrne. "Our Women Are Our Future." *Family Circle* (14, August 1944), 14–17, 19.

Robbins, Trina. *The Great Women Super Heroes.* Northampton, MA: Kitchen Sink, 1996.

Robinson, Lillian S. *Monstrous Regiment: The Lady Knight in Sixteenth-Century Epic.* Garland Studies in Comparative Literature. New York: Garland, 1985.

———. "Looking for Wonder Woman." *Artform International,* 29 (Summer 1989), 100–103.

———. *Mixed Company: Mythologies of Interracial Rape.* New York and London: Routledge, forthcoming 2005.

Short, Robert and Martin E. Marty. *The Gospel According to Peanuts.* 1965; reprinted Louisville: Westminster John Knox Press, 2000.

Spenser, Edmund. *The Faerie Queene.* 1595; reprinted, in *The Poetical Works of Edmund Spenser,* ed. J. C. Smith and E. DeSelincourt. London: Oxford University Press, 1963.

Steinem, Gloria. "Introduction" to *Wonder Woman.* New York: Abbeville, 1995.

Tasso, Torquato. *Jerusalem Delivered,* 1575; trans. Ralph Nash. Detroit: Wayne State University Press, 1987.

Thurber, James. "Thix." In *The Beast in Me and Other Animals.* New York: Harcourt Brace Jovanovich, 1961, pp. 42–50.

Vachss, Andrew. *Batman: The Ultimate Evil.* New York: Warner, 1995, pub-
lished simultaneously in two-volume comic book format.

Wallace, Michele. *Black Macho and the Myth of the Superwoman.* New
York: Dial Press, 1979.

Wertham, Frederic. *Seduction of the Innocent.* New York: Rinehart, 1953.

Index